IMAGES
of America

RED BLUFF

Friend Alice

Whats in thy Heart let noone kn
Or to thy friends or suiter sh
For when thy friend becomes t
Then all the world thy secrets
kn

From a friend

Jos. Florence

Red Bluff.

Mar 3) 1885

A page from the autograph album of Alice Shelton is a remembrance of a common custom. These albums were popular gifts for children from 1860 to the turn of the 20th century. Many such Red Bluff albums survived and are in the author's collection.

ON THE COVER: The Gibson farm was comprised of just a few acres and adjoined the south side of Red Bluff, across the river, but Grandpa Gibson utilized every inch of space to grow several varieties of fruits and vegetables with which to make his living. He supplied such places as the original Tremont Hotel, Cones Store, and others. John Jr. and his family have come for a visit. John Jr. later married Alice Shelton Olson (see page 27). (Courtesy Gibson family.)

IMAGES
of America

RED BLUFF

William Shelton

ARCADIA
PUBLISHING

Published by Arcadia Publishing
Charleston SC, Chicago IL, Portsmouth NH, San Francisco CA

Printed in the United States of America

Library of Congress Catalog Card Number: 2006923161

For all general information contact Arcadia Publishing at:
Telephone 843-853-2070
Fax 843-853-0044
E-mail sales@arcadiapublishing.com
For customer service and orders:
Toll-Free 1-888-313-2665

Visit us on the Internet at www.arcadiapublishing.com

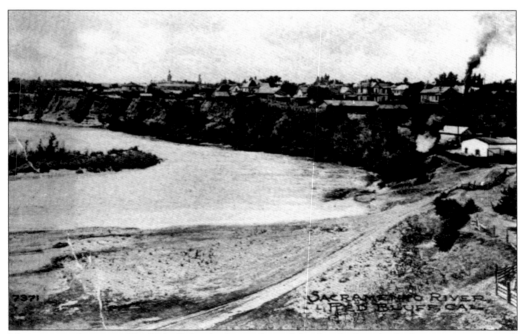

This postcard image of Red Bluff clearly shows the red dirt banks for which the town was named. By the time this image was taken in 1908, Red Bluff had become a thriving shipping center on the Sacramento River.

CONTENTS

Acknowledgments		6
Introduction		7
1.	Red Bluff's Beginning	9
2.	Building the Town	25
3.	Education and Leisure	57
4.	Who We Were: The Pioneers	79
5.	The Original Valley Dwellers	109
6.	The Indian Fighters	119
7.	Miscellany	123

ACKNOWLEDGMENTS

Many people who lived in and around Red Bluff over the years were hunter-gatherers of a different sort, collecting vast amounts of data as well as information in the form of documents, photographs, albums, and papers. It is with much pleasure and thanks to these people that I write this book. You see, I was taken under the wing of several historians when I was very young. Coming from several pioneer families of Tehama County, I was bequeathed entire collections from other historians. Many of them have merged to form a valuable source of research that I call the Gathering Grounds Museum.

I wish to thank Alice Shelton Olson, Emma "Red Wing" Gray Shelton, Ruby Swartzlow, Velma Butler, and Martha Taft Slade. These people not only encouraged me but also gave me a multitude of priceless "stuff." A special thanks goes to historian Opal Mendenhall of Red Bluff as well as Rochelle Button of the Tehama Cemetery District for the Thomes information. The final collection now rests in several locations in California: a restored Victorian mansion (the Bruce House) in Chico, the 49er Ranch in Magalia, and the restored Odd Fellows Hall in Durham. The last of these now houses the Gathering Grounds Museum.

Original research done by Lois Halliday McDonald over many years and given to me contributed greatly to this completed work. Lois, who died of cancer in 2005, not only was a dear friend but "a Historian, and very much so!"

No single book can encompass the story of a community that is as diverse and long-lived as Red Bluff. Only bits and pieces and recollections can attempt to unite yesterday with today using fragments of 150 year's worth of information. Most of this book's captions were compiled from actual interviews with Red Bluff pioneers during the 1950s and 1960s and have been shortened to fit the format of this book. So researchers beware; these captions contain much of that imperfect oral history and should not be relied on as a literal source.

This book, as all others, will present opinions and questions. But no one book can answer all questions or quench all curiosities as well as present a full historic account.

—Bill Shelton
Historian, Researcher
Chico, California

INTRODUCTION

No one knows exactly when the first white men came to view what would become the site of Red Bluff. There are reports that such people as Jedediah Smith, William B. Ide, Peter Lassen, and others saw the land as early as 1835.

During the gold rush, an influx of people coming and going on their way to the gold fields brought settlers to the struggling little town and helped to expand it greatly.

Duncan Heights, as it was known in the beginning, had no organized government. The 1840s saw the building of the Meyers Hotel, and in 1850, the steamer *Orient* took a chance during high water, steamed past Tehama, and anchored in the river below the steep red bluffs.

In 1851, a stage line was started that connected Red Bluff with points north and south and expedited mail on a regular basis. As early as 1856, Red Bluff had become the largest city north of Marysville, and by 1860, the population topped 2,000. In 1872, the railroad reached Red Bluff, and at this time, it became a chief center of freight commerce to Oregon and Idaho.

Many small communities had sprung up almost overnight only to die back down as better pickings were discovered elsewhere. One such community sprang up when a wagon train of immigrants landed in early day Red Bluff only to find all the best lands taken and so they chose to settle in an outlying area where present-day Highway 36 takes off up the hill from the flats towards Paynes Creek. They called their settlement Missouri Hill and built cabins and outbuildings. Yet when they discovered after a year or more that there was no gold to be found, and being destitute, the wagon train set out for Oregon. Other areas, such as Carolina Flats, Slim Pickins Gulch, Tennesseeville, Frying Pan Flats, Oregon Gulch, and many others, served as camps for settlers and gold seekers.

Also playing an important part in the history of the area were the Indian fighters and the final, or "Last Battle of the Millcreeks," which took place April 14, 1866, atop the north rim of Deer Creek. After the attacks on the homesteads of Albert Silva and Bolivar Mckee on Mud Creek, all-out war was waged on the "Indians," who went into hiding. But almost all of the Native Americans were tracked down and killed. Many mortar holes in the lava rocks bear witness to their early numbers and are visual reminders of the unrelenting effort to extinguish them from their ancestral grounds by the migrating whites.

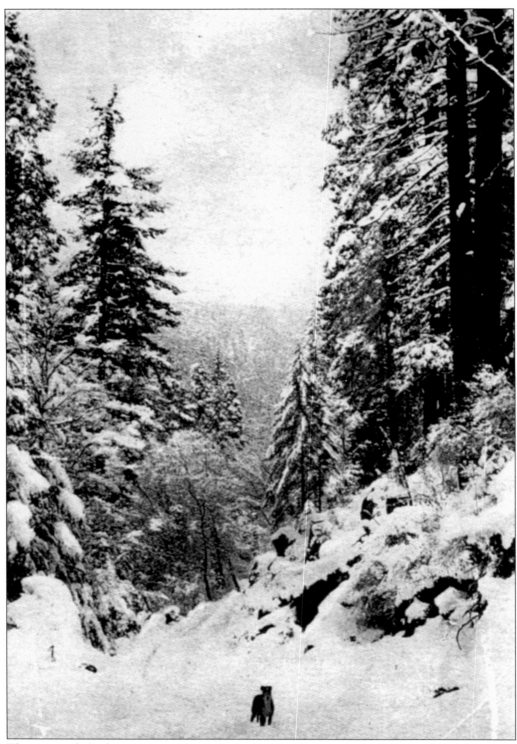

This postcard, displaying a scene "not so" near Red Bluff, was mailed in 1913 by Beulah Gosney.

One
RED BLUFF'S BEGINNING

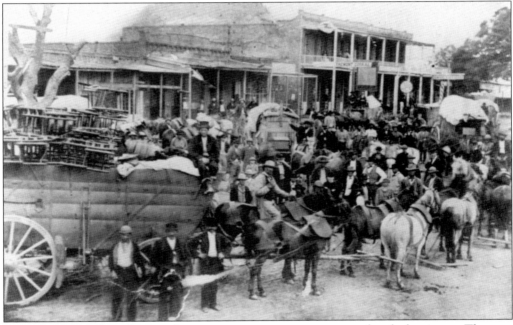

Dates vary as to when the very first permanent structure was erected and what it was. The very earliest structure seems to be a "rude cabin" that occupied a spot under the "Hanging Tree in 1853." (Moulton Archives.) But probably the earliest permanent brick structure was the assay office containing the Farmers Union, Tremont Hotel, and connected to it, the tiny store of Cone and Kimball. Cone and Kimball would later become giants in the community with their turreted building. Tarping was in short supply, and when wagons would come in with freight, the canvas wagon covers were often bought by Cone and Kimball, converted into roll-down awnings, and sold to other businesses. Red Bluff was a melting pot for commerce coming to and from several western states. With the opening of the Sacramento River to commerce after periodic dredging to accommodate paddle wheelers, Red Bluff was open not only to a wealth of supplies but also a wealth of cultures.

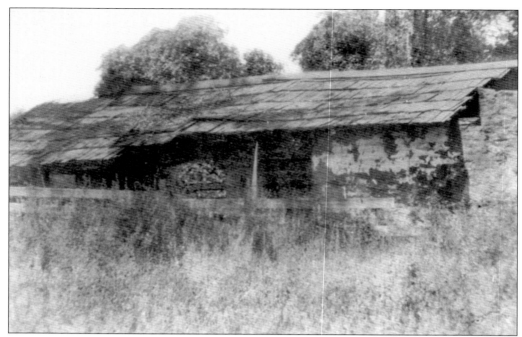

Peter Lassen's original adobe barn actually served as his first living quarters at Benton City until his house was finished. Built in 1847, this barn existed until the 1950s when the final traces dissolved from rainwater and neglect. The blocks were made from mixing mud and straw. Peter Lassen may have been one of the first white settlers to sojourn in what became Red Bluff, camping out there while chasing thieves who had stolen horses from his rancho in 1843.

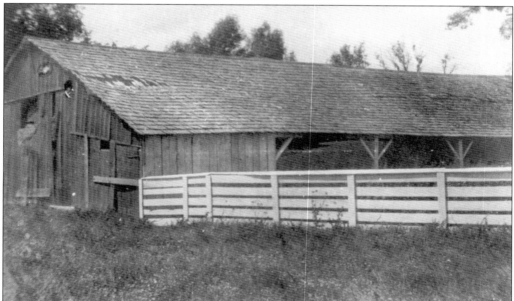

Lassen's barn, located several hundred yards up creek from the adobe, was built with hand-hewn beams and mortise and tenon construction with square nails and pegs securing it. The hardware was made in the blacksmith shop on the property.

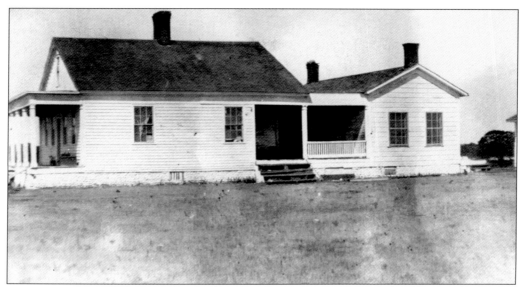

This is one of the last remaining photographs of Benton City. The city was laid out in 1847, but many of the buildings were not constructed until 1848–1849—the call for builders from the East wasn't answered until then. Pictured here is "Uncle" Billy Mayhew's house, which was actually two houses joined together by a breezeway.

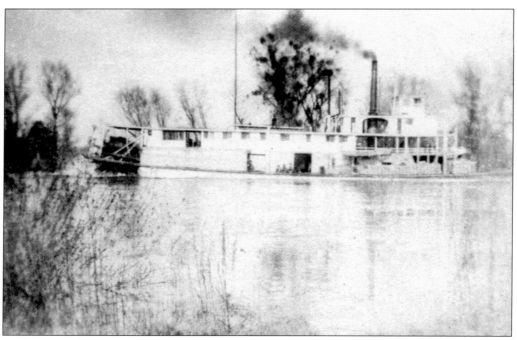

In this 1860 photograph, the steamer *Lady Washington* tries to free herself from a sandbar with snags. As she gained "full ahead" speed, a hole was gashed in the bottom that proved to be her end. She was purported to have been the first steamboat to come up the river and had been put into service by none other than Peter Lassen himself in 1849. (Photograph courtesy Hobart Moulton, Loomis collection.)

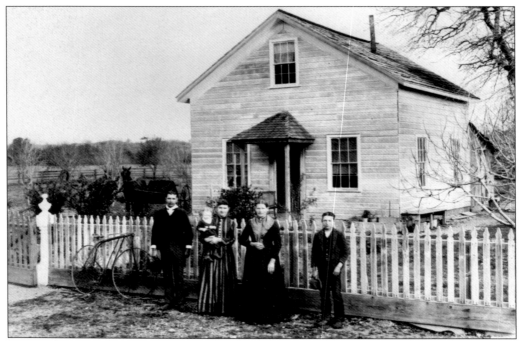

Peter and Anna Heibner built their home on Dibble Creek, near the present Highway 36 about two miles west of Red Bluff, in 1869. Prominent landowners, the Heibners opened their second floor to overnight travelers. Pictured here, from left to right, are Clay Heibner, Baby Josie, Carrie Heibner De Haven, Anna Heibner, and Plumas "Plumie" Heibner. The barn, made with lumber from the Champion Mill at Lyonsville, was still standing in 1972. (Photograph by R. F. Stinson, 1893.)

In the beginning, large boats that made their way up the river had no place to land and were often met mid river to off-load supplies onto lesser vessels such as this small boat. This scene near the bridge reveals the red mud banks that had to be surmounted. In place, and attached to the bridge's foundation, were heavy chains to which large boats could tie off.

"Hank" Bressler and family are pictured here in front of their Antelope Valley house. Bressler was a well-known stage driver who drove the Lassen route. Mrs. Bressler fed and boarded travelers, tended an impressive garden, and raised a large family. Outpost hostelries were very important as Red Bluff realized a steady influx of traffic going to and from the gold fields of California, Oregon, Montana, etc.

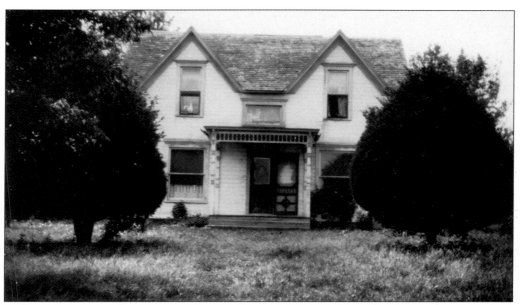

William Gurnsey and wife, Miranda, owned a vast amount of land bordering the river where present Gurnsey Avenue and Highway 99 are today. The Gurnsey family were pioneers of Taylor Valley and were acquaintances of Peter Lassen and W. B. Ide, who married Sarah Cooper, Mrs. Gurnsey's niece. The Gurnsey house was built in 1868.

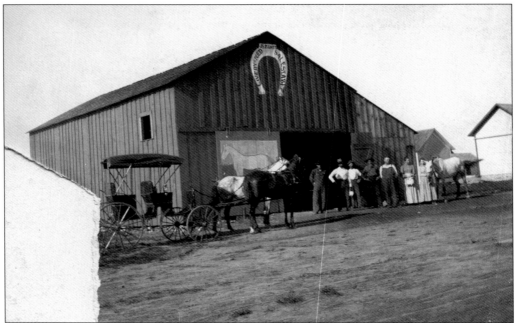

J. S. Hunt's Livery stable, seen here, was originally used as William Gurnsey's stock barn, built in 1868 to house his horses and cattle. A large addition was built on the right side of the barn that bore a very primitive painting of a horse on the door. Hannah J. Gurnsey Curry and Mary H. Gurnsey Hunt are standing by the white horse.

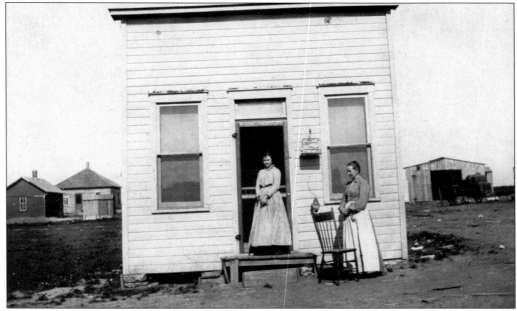

Mary Gurnsey Hunt's husband, J. S. Hunt, promoted the annexation of his father-in-law's land to the City of Red Bluff. But commerce here was short-lived as people chose to trade in town. These buildings were later moved into town. Mary Hunt, pictured here on the steps, stands in front of the "Huntsville" post office with her sister Hannah J. Gray Curry.

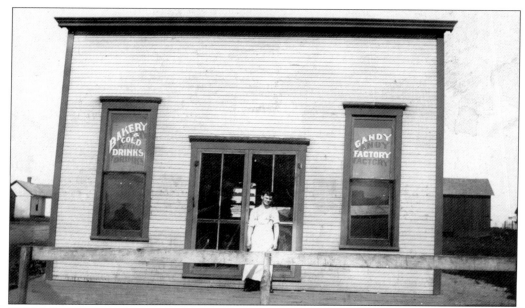

"Will" Gurnsey ran the candy store and bakery. This building was later moved to the rear of the Tremont Hotel when fire destroyed the livery barn. The new addition to the Gurnsey livery barn can be seen on the right side of the photograph. That's not a fence in front but a hitching post for horses of the crowds that were expected. As can be seen, this "town" had but a short life. (Courtesy of Forest Gurnsey.)

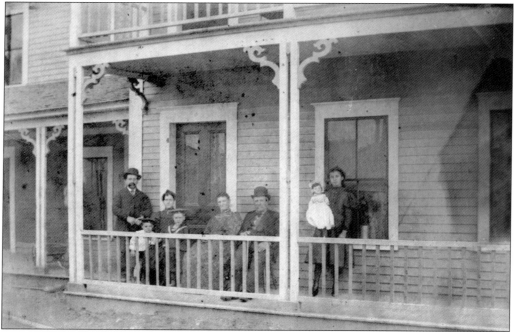

The Moulton House was actually a Victorian hotel built in the 1860s at the south end of Jackson Street. Eli Moulton, his wife, Belle, and their two children are pictured at left. Eli's parents are seated center, and the lady with the doll is unidentified (Courtesy Hobart Moulton.)

Oak Street was building up when this image was taken around the turn of the 20th century. Roads were wide to let large loads pass. Oak Hill can be seen on the left with its towering oaks.

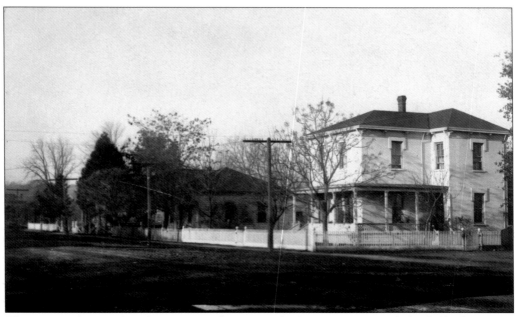

This view of part of Oak Street in the 1880s, looking west toward the hill, shows the permanent structures that went up along with rows of smaller homes. This brick house was torn down in the 1950s.

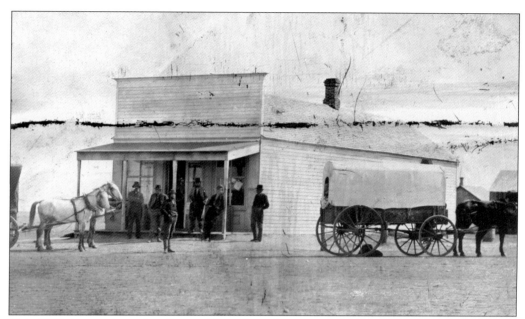

This 1867 tintype from the album of Eura Pitts shows covered wagons in front of the general merchandise store across the street from the original Cone and Kimball store and Tremont corral. Eura's father, Euriah Pitts, was the proprietor.

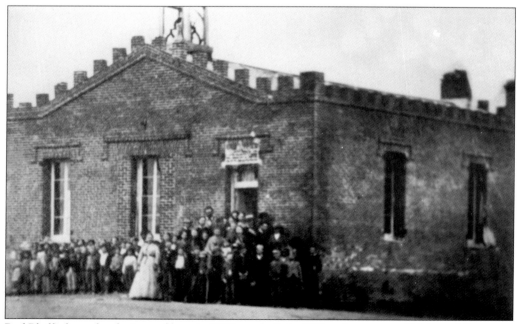

Red Bluff's first school, pictured here in 1863, was built in 1853 at the corner of Main and Sycamore Streets. A cannon that misfired at a Fourth of July celebration caused the damage above the window. Luckily school was out for the day. (Courtesy Hobart Moulton.)

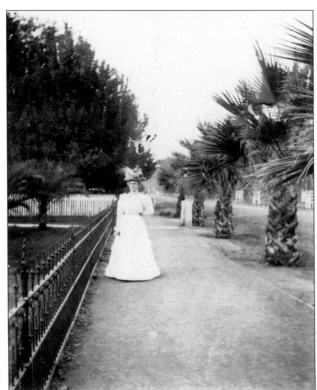

Red Bluff boasted some magnificent homes and much pride was taken in public streets and plantings. Almost every house had a fence. This is Cora Abbey Eliott taking a stroll by the many palms that graced Red Bluff in the early days. The Eliotts were paddle-wheel boat owners who also maintained a house in Sacramento City. The fence at the Stoll house can be seen at the back left.

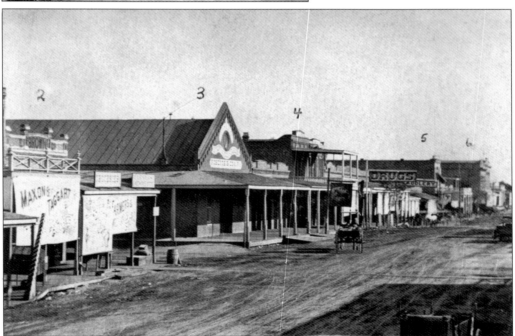

This early street scene simply says "Walnut Street—Red Bluff 1868" on the back. Any other caption that may have accompanied the photograph is long since lost.

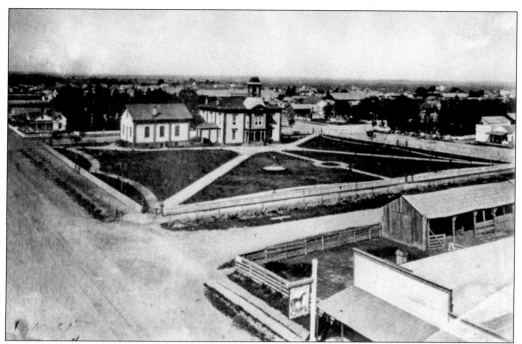

Red Bluff Courthouse Square comprised a whole city block, as seen in this above 1907 image taken from the water tower above the stables. The jail is annexed to the courthouse and could house about 40 prisoners comfortably. The jailer's house is at the far left across the street. In the foreground is the familiar "horse" sign that hung in front of H. C. Wietfeldst's horse shoeing barn. This "shoeing" barn was later incorporated into the Bidwell Brothers Carriage and Wagon Manufactory business. Seen below is a later image of the courthouse square showing landscaping and the dignitaries who worked in the building.

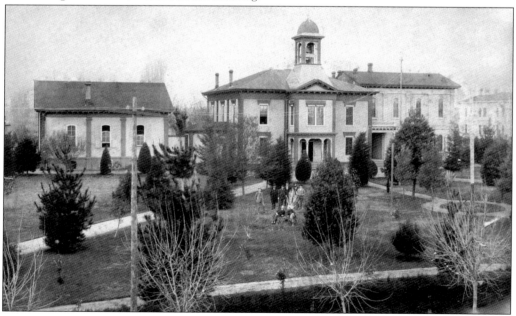

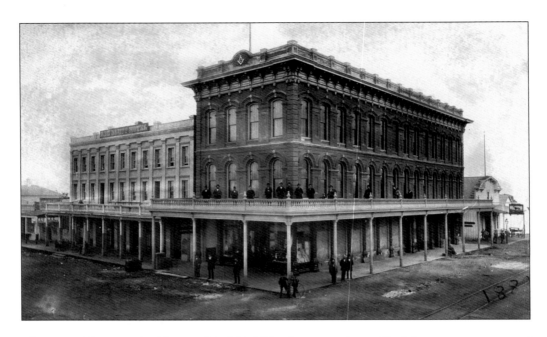

The original Masonic Building and Red Bluff Hotel are seen above. The Masons were very proud of their new building, which took three years to erect, only to burn down a few months later. Lining the balcony are 32nd Degree Masons. The Masonic order, as well as the Odd Fellows, always rented out the first floor of their building to defray the cost of construction. Pictured below is the Old Masonic hall interior. The interior of the original Masonic temple took an entire year to complete and was elegant even in those primitive days. No expense was spared—Brussels carpets, walnut furnishings, velvet drapes, and faux ceiling were completed with four coved oil paintings of local scenes.

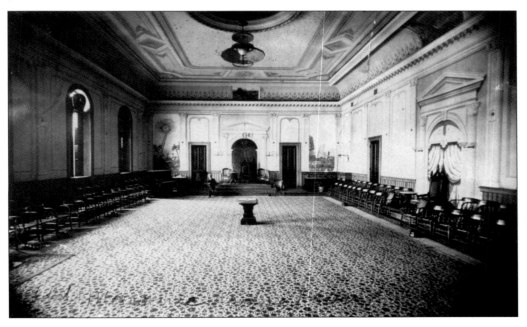

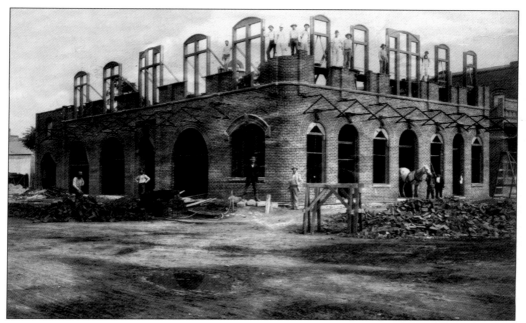

Here Red Bluff City Hall is under construction. This photograph was taken by John Clements, who noted on the back, "The bricks were made Down River by Chinese and hauled to the spot." Begun in 1884, Red Bluff City Hall was completed 14 months later.

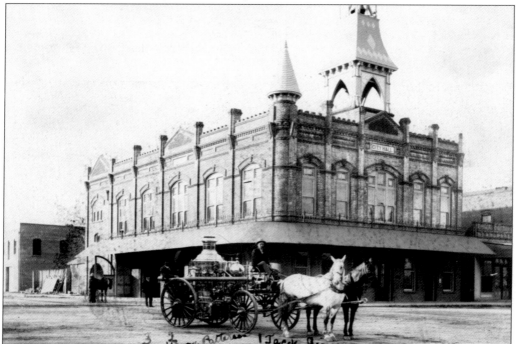

The finished city hall is seen here around 1896. It also housed the hose and ladder company. Harvey Patterson and Jack Ginn have just pulled the engine out of the firehouse (left). Red Bluff maintained several fire companies at once to ensure that the entire city was adequately protected.

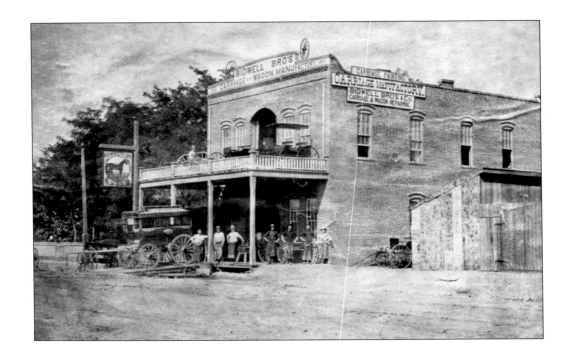

Bidwell Brothers Carriage and Wagon works and stable was well equipped to deal with all aspects of vehicles as well as horses. The above image shows the stagecoach from the Tremont Hotel, which was a gift to the owners from general contractor Frank Hendricks. The entrance of Bidwell Brothers Carriage and Wagon Manufactory is shown below. Jonas Jensen (left) was the smithy, or blacksmith. The other two men are unidentified.

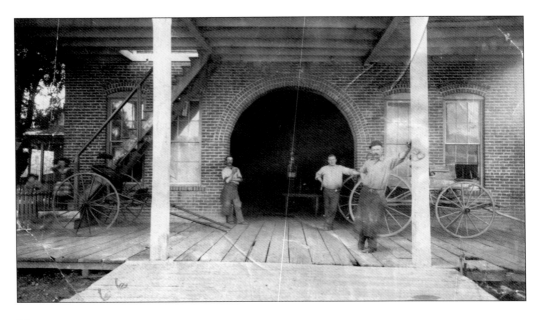

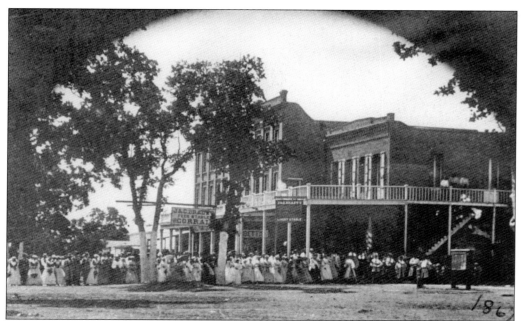

Red Bluff town square is pictured here on the Fourth of July in 1867. By that time, the town was well established and many of the finer things of life were coming up river via paddle wheelers. It was around this time that much cheaper board-and-batten houses were being replaced with large elegant houses of both brick and wood frame. Note the famous Hanging Tree.

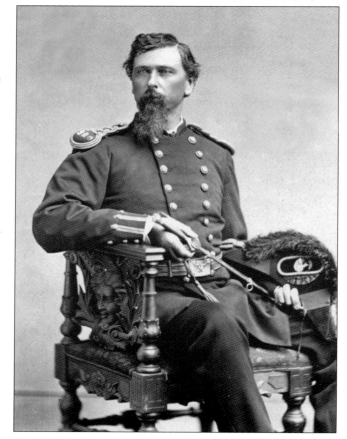

Maj. John Brady, Red Bluff pioneer and businessman, poses in this 1882 photograph taken by Kusel, a traveling photographer of the time. Brady was a Freemason for many years in Red Bluff.

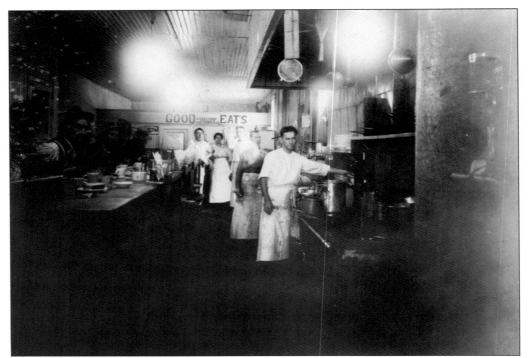

One of Red Bluff's oldest buildings was the assay office that shared an exterior wall with the new Tremont Hotel. A very narrow building, during hard times and the Depression, it was converted into the Good Eats House. To date, there is no other photograph of the inside of the old assay office. It later became Cone and Kimball's first store.

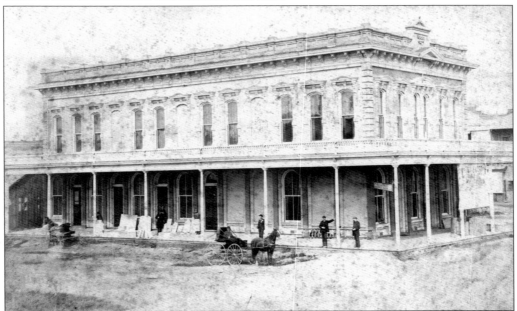

The Odd Fellows building, pictured here just after completion in 1884, also housed Mrs. Pitts's Millinery and Dress Making shop and, on the side street, the granite and marble works.

Two

BUILDING THE TOWN

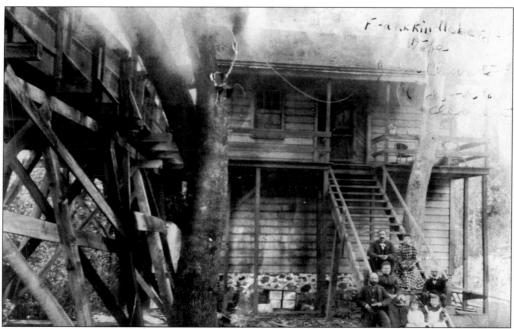

High up in Antelope Canyon, the Sierra Lumber Company flume was guarded by John Clements's father, whose first name is not known. The flume, which ran from Lyonsville to the Sacramento River at Red Bluff, often developed lumber jams. Seen here are three generations of the Clements family. Franklin Moberly and wife (at top) enjoy a pleasant day. Both water and lumber were essential to building the town of Red Bluff, and water from this flume was diverted to the Huntsville side of the river for crop cultivation. The stone foundation of the Clements house, seen here, is actually a spring box that kept fresh water cold. It still exists today along the track of the old flume, although its covered with brush and dry grass.

William Gurney's daughter Hannah Jennette Gurnsey Gray, seen here in her 80s, still kept a house on the street named for her family, Gurnsey Avenue. She had an eventful life. Abducted from her parents' wagon at an early age by the Mill Creek Indians, she escaped two years later. Eventually marrying James Emory Gray, she lived on Hogsback Summit's Shakehouse Ravine until James died. Returning to Red Bluff, she lived for many years and was buried in Belle Mill Cemetery in Lyonsville next to James Gray.

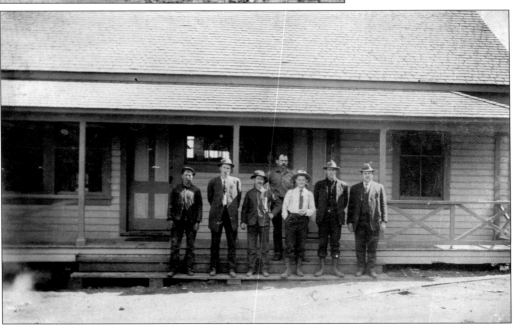

The Switch house, one of the first buildings constructed when the railroad came to Red Bluff, also served as a depot in the early days. Pictured here, from left to right, are Frank Chambers, John Mason, Ed McGhie, Buck Jones, Al Chambers, John Clough, and Harry McClure.

Argonaut George Franklin Morris came from New York in 1854 to Sacramento City. He built the Log Cow Creek School and taught in Antelope Valley. Although he also raised stock horses, he should not be confused with the George F. Morris shown on page 107.

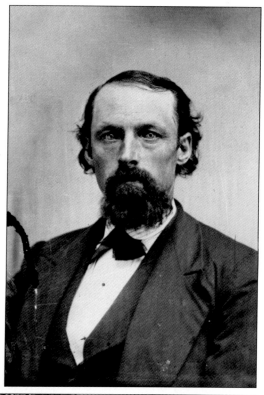

This is the family of James Gibson, brother of John Gibson Sr. James and his wife came from Oregon Territory where he had prospected. The Gibsons also lived on brother John's property. In this photograph, James Gibson's son Tom is standing with wife, Helen (right), her sister, and their two boys, Tom and John. The youngest boys are shown in dresses, as was the custom in those days for formal portraits.

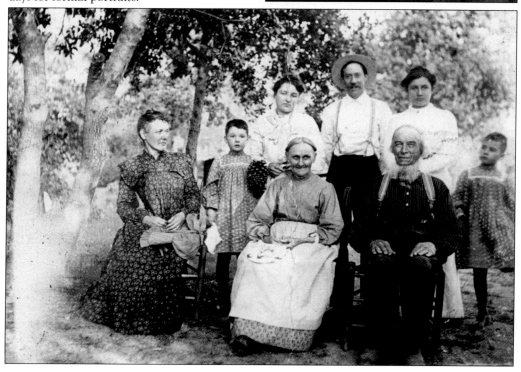

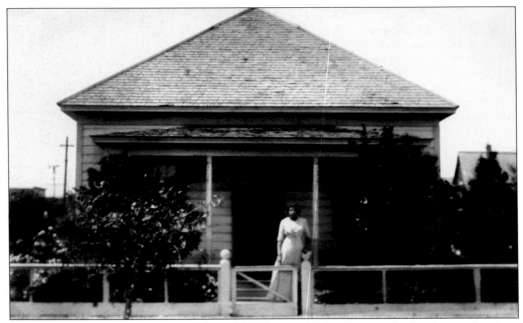

The Olson house was built in 1887 by Adolf Olson and John Custis, who lived next door in a house he built in 1868 after the Civil War. By the time this photograph was taken, electricity had come to Red Bluff. The pine tree to the right of the house is now a mature tree.

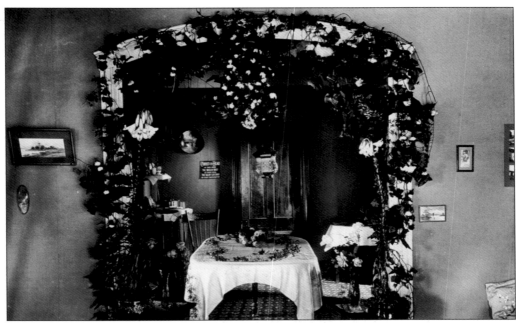

The parlor at the Adolf Olson home is decorated for a somber event. It is June 5, 1917, and one of the three Olson sons, Jakie, has just been buried in the family plot at the Oak Hill Cemetery. The family owned a great deal of land that later became Lassen National Park, and Jakie Lake in the park is named for the little boy being mourned here.

John Custis's Bible, on a chair in his living room, displays the bullet hole that penetrated his uniform pocket watch and finally came to rest there, ultimately saving his life. The bullet remains lodged in the Bible and is now part of the collection at the Gathering Grounds Museum in Durham, California. This photograph taken in 1872 is from the Olson photo album. Custis lived on the 1400 block of Second Street in Red Bluff at the time.

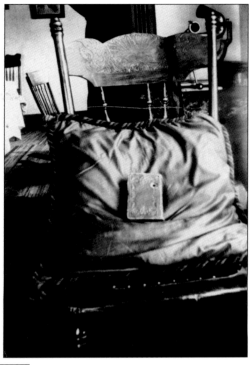

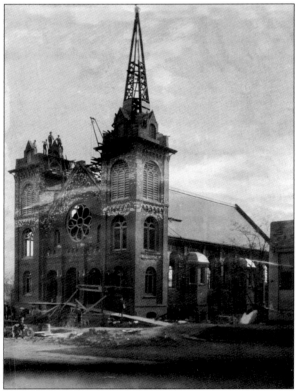

Sacred Heart Catholic Church, pictured here as the steeples are being added, still stands on Main Street. Beginning around 1906, the structure took two years to build. Workmen first realized there was a problem with construction when a few weeks after the church was mortared some of the bricks became so soft that local children were writing their names into them. Many of the bricks also turned a pale tan color, which made the whole building look like a patchwork quilt. The final remedy was a thick, red stain that workmen coated the entire building with from top to bottom. Note the man sitting on the very top of steeple.

29

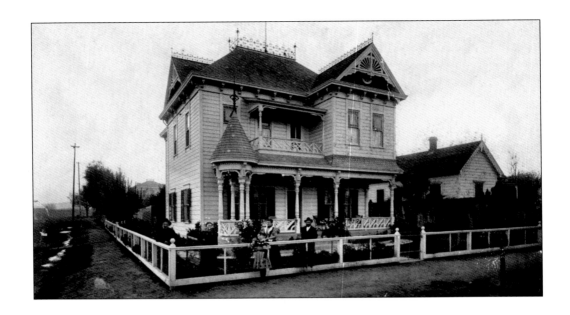

John Clements's home at the corner of Main and Ash Streets was one of the most beautiful of Red Bluff's Victorians. Built entirely of cedar and redwood, it contained 12 rooms, a summer kitchen, and beautiful gardens. Pictured here is the Clements family in their yard. The successful business that funded the house is shown below. John Clements and three of his unidentified store employees stand in front of the post office portion of the store. The U-shaped store had two entrances, with the post office at the right rear. On the opposite page is a view of the same store looking in the other direction.

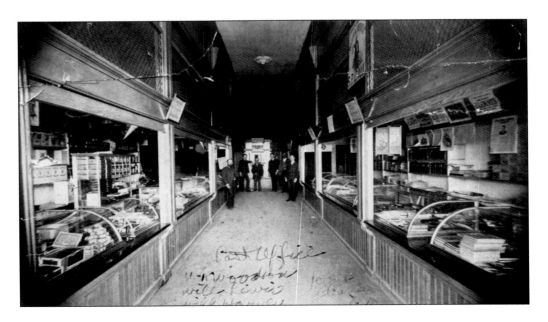

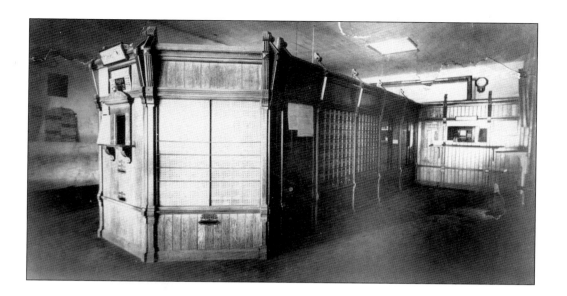

The post office above was housed in the right rear of John Clements's Cash Store and was used between 1880 and 1884. It was a very up-to-date building, complete with four slots for outgoing mail with destinations north, south, east, and west. Below is the interior of the left half of John Clements's Cash Store. "We deal only in Cash" was the motto as displayed on the sign. Pictured here are Warren Woodson, Will Harvey, Will Lewis, John Clements, and two unidentified men.

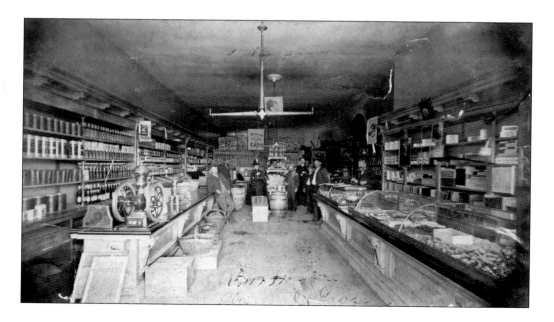

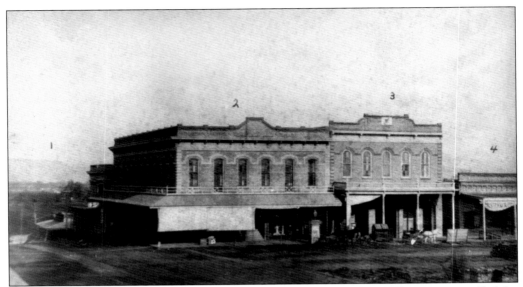

The new Masonic corner displays the drop-off to the Sacramento River. This area was called the Steeps. The ground floor housed John Clements's Cash Store and the post office and connected to what would become Kingsleys Opera. This was one of Red Bluff's busiest corners for 40 years.

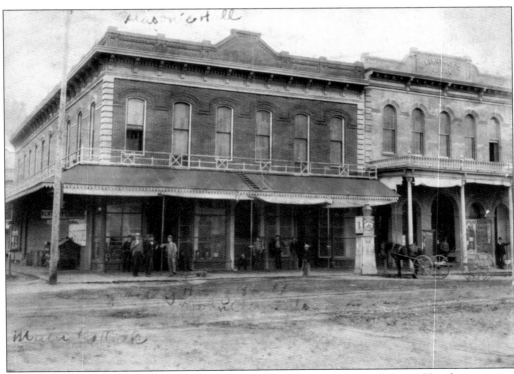

This is another view of the new Masonic building showing Clements Cash Store. Here businessmen have gathered, including John Clements (with beard). Kingsley's Opera house is showing *Dr. Jeckyl and Mr. Hyde*.

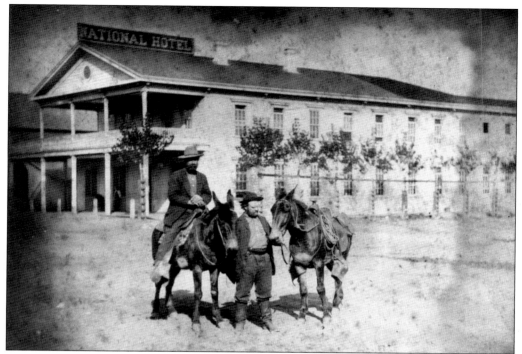

The National Hotel first opened in 1877 and was built by Henry Miller, seen on the porch in 1878. Standing at the corner of Main and Hickory Streets, it had the first outdoor café attended by waiters. It was later known as the Imperial Hotel and Cone Tower. The men in front are Will Avery (left) and Addis McClure.

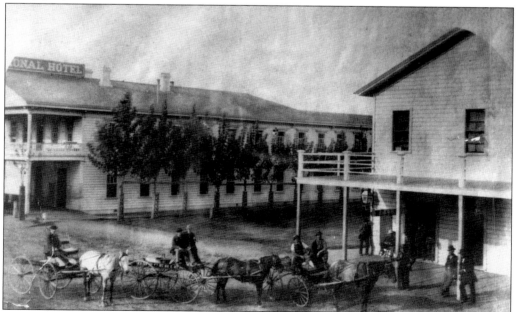

The Occidental Grocery and Meal House is pictured here in 1880 with delivery wagons. Note the growth of trees in this photograph and the one at the top of the page.

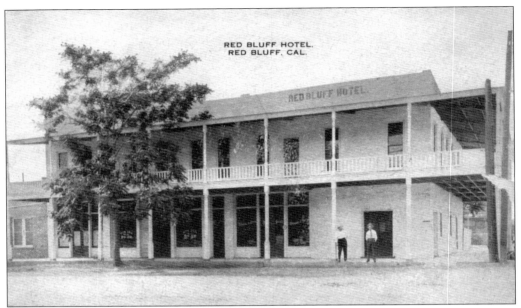

This is Red Bluff Hotel in 1918. Built as a brick structure just after the turn of the 20th century, it was later covered with stucco.

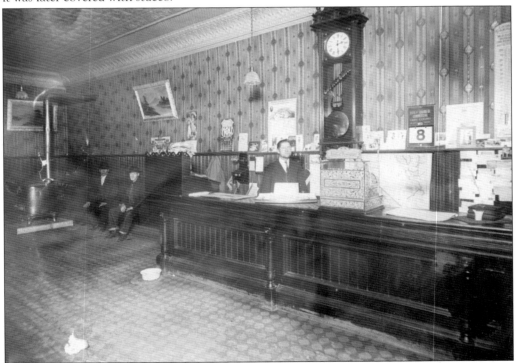

The lobby of Red Bluff Hotel, seen here, was a gathering place for locals who enjoyed the long benches. Judging from the Bank of Tehama County calendar hanging on the wall, as well as a clock, this photograph was taken on Wednesday, December 8, 1912, at 2:30 p.m. Hamlin Procter is on desk duty.

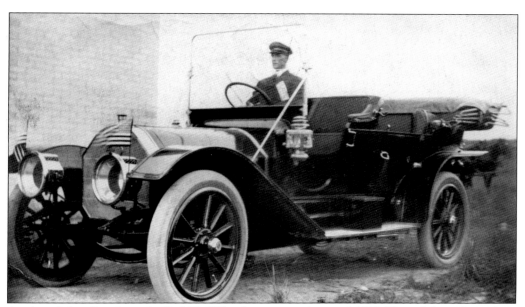

A cab and chauffeur from the Red Bluff Hotel are pictured around 1928. The cab ferried people to and from the train depot and the Sacramento River. The chauffeur's name is Clyde Ellsworth.

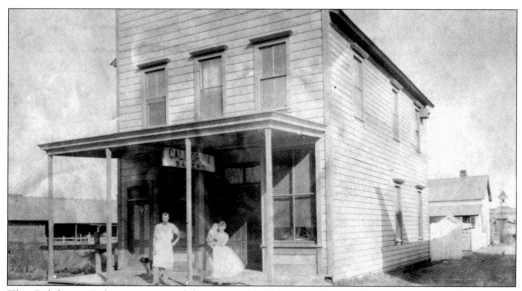

The California Bakery was one of the original buildings in Huntsville, an early town built across the river. It was moved to this location in Red Bluff and eventually burned.

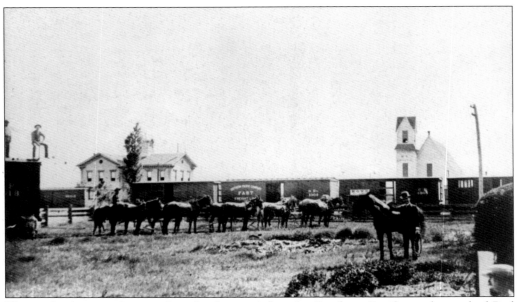

This early photograph was taken the first year that the Southern Pacific tracks reached Red Bluff. Looking west (left) is the Oak Street School. It was a common practice to use horses to pull train cars onto sidings to let other trains by, as engines were in short supply. The man on the handbrake is Ed Myers of Lyonsville.

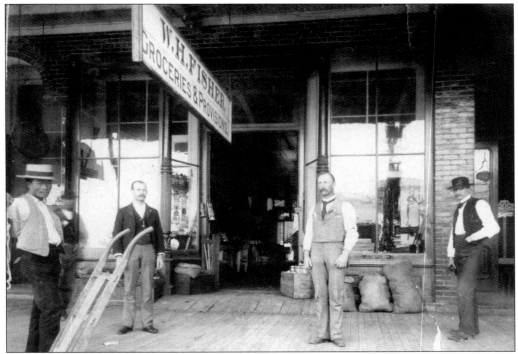

This is a view of W. H. Fisher's Groceries and Provisions store on Main Street. It was a very early store and served also as a post office. This store was so successful that it was torn down and a grander building constructed on the same spot.

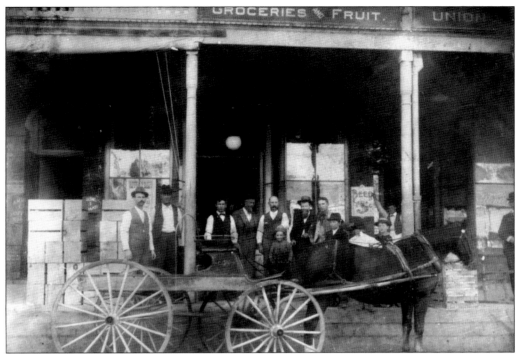

The W. H. Fisher Company Store on Main Street, along with the proprietor Will Fisher in his topcoat and vest, are seen here with the company employees. Fisher also owned the adjacent saloon to the right of his store. Originally started during the gold rush as W. Fisher Provisions Company, it first sold bulk groceries to wayfaring miners and traveling wagon trains.

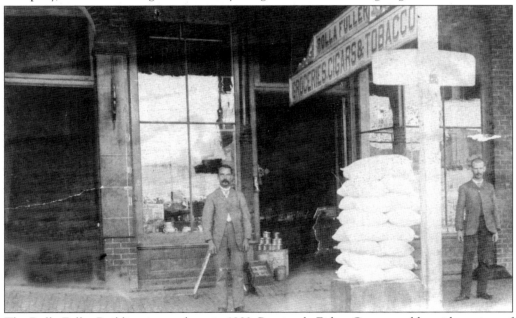

The Rolla Fuller Building is seen here in 1889. Previously Fisher Grocery sold a wide variety of locally grown produce. The Fullers were friends of the Fishers.

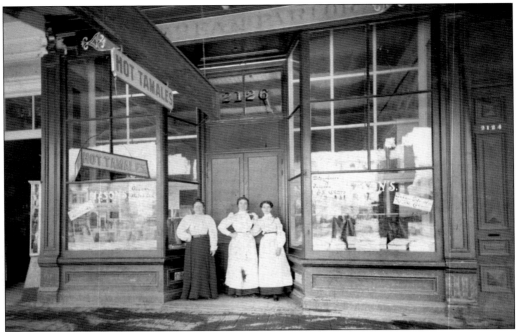

Mason's Ice Cream Parlor offered the best hot tamales in town, and the sign reads, "Hot Tamales, Ice Cold Lemonade, Strawberry Ice Cream, and Shaved Ice." Eva Dunn, right, is the only person identified so far in this photograph. The parlor was a favorite place to relax on Red Bluff's searing hot days.

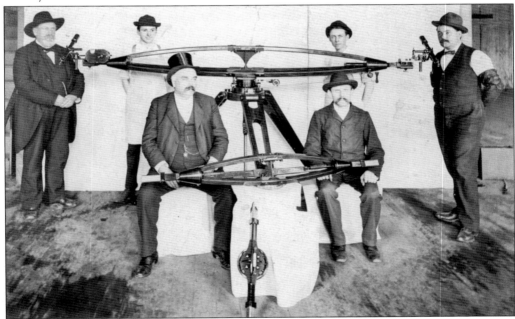

This image is captioned, "Taken aboard the *Dover* on the way to Red Bluff." It carried very little information other than the notation that these are surveyor's instruments. The *Dover* was a well-traveled riverboat that plied the waters between Red Bluff and Sacramento City.

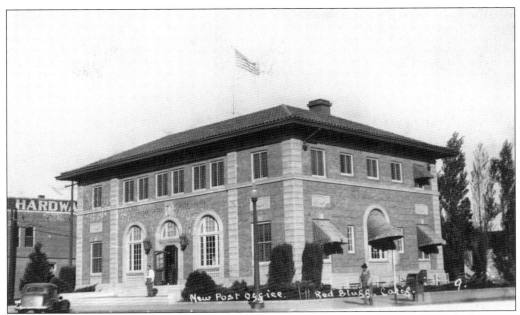

Early day correspondence was sent by way of riverboat or stage. The first post office, which was no more than a counter in the Sunset Telephone and Telegraph Company, opened onto the street. It was replaced with the new post office pictured here.

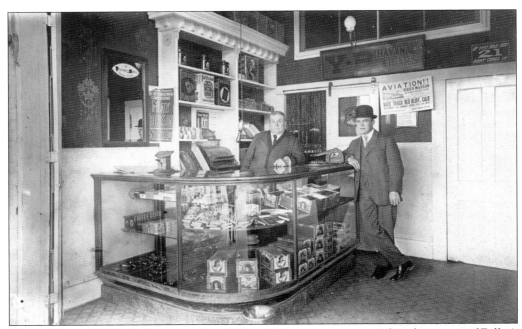

Harvey Proctor (behind the counter) and "Boon" Epperson are captured in this image of Fuller's Grocery and Tobacco Store. Note the sign advertising an Aviation Show at Red Bluff Racetrack. The sliding door behind the counter led into a "conditioned" sawdust-lined humidor room that backed up to cold storage at Fuller's store. A bar was housed through the door to the right.

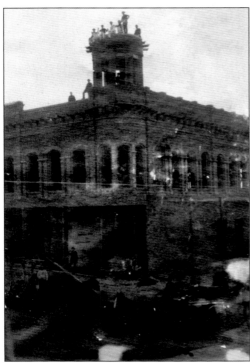

This image above, taken during construction of the Cone and Kimball Building, shows workmen just finishing the brick structure. G. G. Kimball was very annoyed that work slowed when the four clocks that were meant to grace the tower arrived with specifications not matching the structure. The woodwork and turrets had to be redone. Below, J .S. Cone and his wife pose for a photograph taken shortly after their marriage.

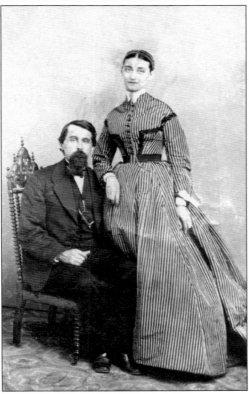

Joseph Spencer Cone was born August 26, 1822, in Massachusetts. Coming to California in 1851, he settled on Alder Creek in 1857. By 1868, he had acquired 100,000 acres in Red Bluff, from Antelope to Mill Creek. In 1871–1872, he financed the Antelope flume, the first in California. He established Tehama County Bank and was vice president until he died. He remained a silent partner in the Cone and Kimball Company, as he reportedly could not handle the stress of the retail business.

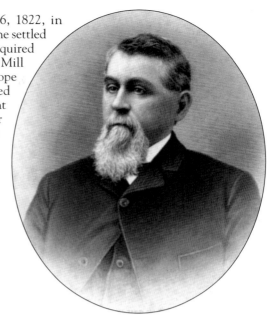

Maj. Gorham Gates Kimball was born April 5, 1838, in Maine. He came west in 1860 to the Tehama area with $35. This photograph was taken in 1862, the year he arrived in Red Bluff. He made much of his original fortune with a herd of 50,000 sheep and became owner of the first building that would become Cone and Kimball Company by 1876. He ran Cone and Kimball and oversaw all of the construction, He owned many steamships as well. His partnership with J. S. Cone was an alliance of seasoned businessmen.

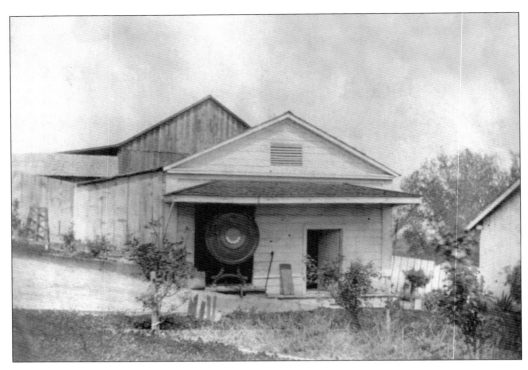

The image above shows the old gas works constructed in the 1880s at Red Bluff. It was operated by J. B. Smith, who was also a butcher in town. Below, Smith and his wife enjoy a sunny January afternoon on the porch of their cottage at the old Red Bluff Gas Works. The Smiths maintained a large garden and orchard on the property.

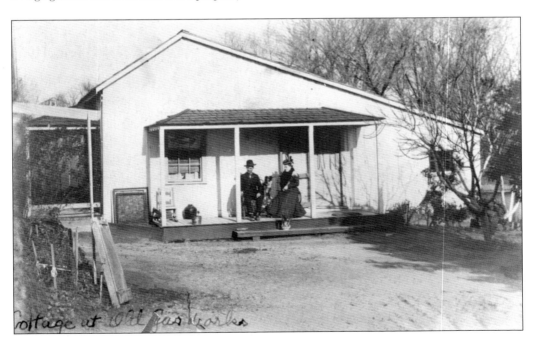

Cottage at Old Gas Works

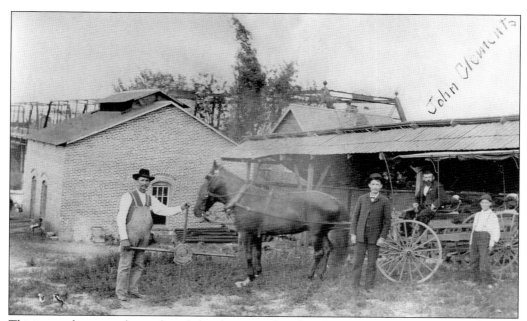

This image shows pipe being threaded at the gas works. Though the gas works was located elsewhere, their pipe yard was just below the bridge. John Clements, who is in the surrey, was the owner.

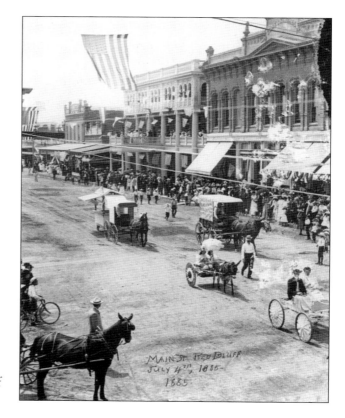

During Red Bluff's early heyday and building boom, many beautiful structures were created. Two of the most famous to locals were the new Tremont Hotel and the Cone and Kimball Building with its fourth-story clock tower. Red Bluff was still a little rough and tumble in this 1885 Fourth of July photograph.

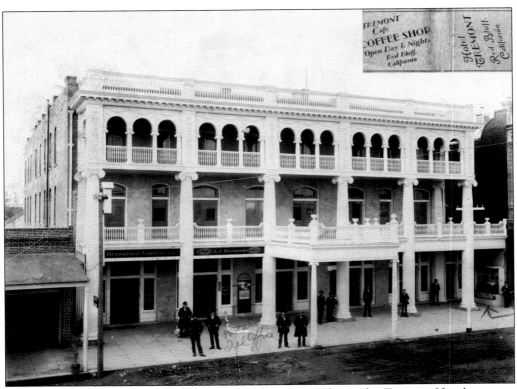

This is the Tremont Hotel around 1930. The Hotel Tremont Coffee Shop replaced the Postal Telegraph Company and the Tehama County Land Company, which were housed in the lower left of the hotel 30 years earlier. At the top right is a matchbook cover from the coffee shop.

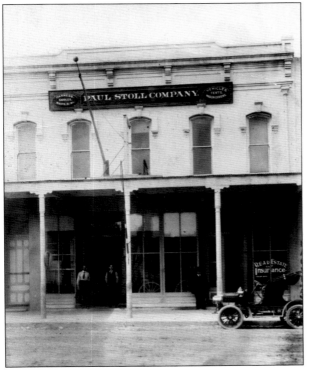

The Paul Stoll Company was mostly a business that sold buggies, wagons, wagon covers, and many custom-made items in leather and canvas stored at another location. A custom sign painter worked for the firm, and it was this company that did most of the lettering on downtown business windows, wagons, and signs. The company lasted over 40 years and rented out space to the real estate office.

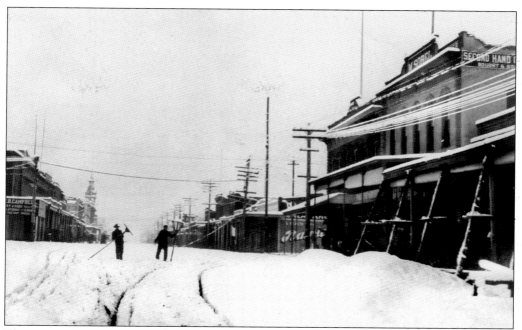

This snow scene was captured in 1907, looking northeast. Alva Olson (left) and Jeff Payne are making money by raking snow from awnings. Cone and Kimball Company's clock tower is at left. Snow was rare in Red Bluff.

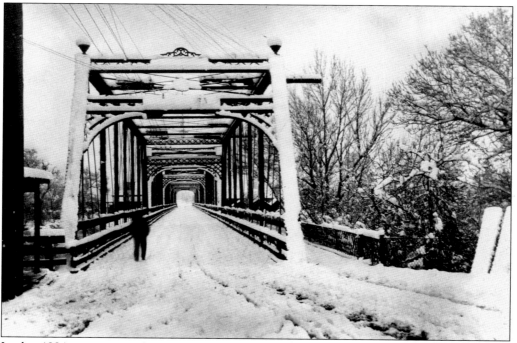

In this 1884 snow scene, Centennial Bridge is covered with eight inches of snow. Rains came shortly after and caused flooding across the river from Red Bluff. The road beyond the bridge actually vanished for several weeks until waters subsided.

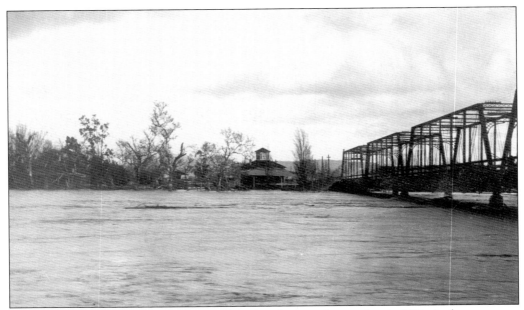

The Sacramento River was at flood stage when this photograph was taken in 1912. And more storms caused the river to crest within inches of the bottom of the bridge. Guards (known locally as "River Pigs") were posted on the bridge day and night to keep debris from snagging on the bridge.

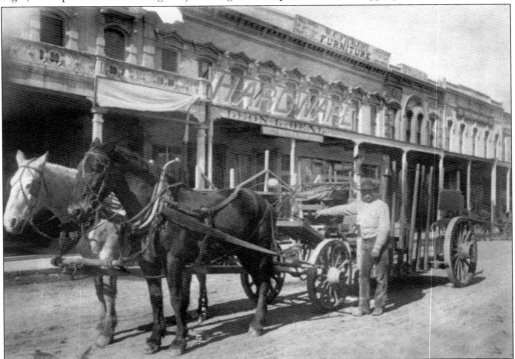

This Main Street scene shows Albert Proctor and his tinkers wagon in front of Filberts Furniture and Beal's Hardware store. By the turn of the 20th century, almost anything could be purchased in Red Bluff.

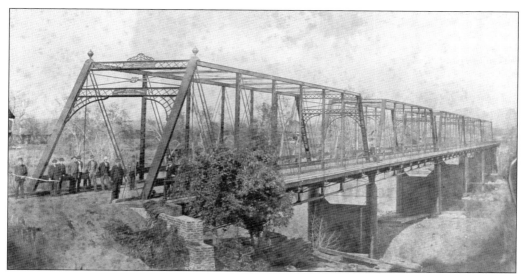

The construction of Centennial Bridge was contracted out to Pacific Bridge Company of San Francisco and delivered in pieces via river barge and train. The foundation had already been set when it arrived, and the river was diverted to pour the footings. Note the 1884 date on the bridge. It was actually built in 1876.

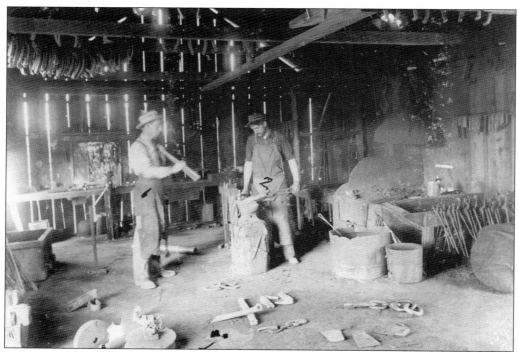

Moore's Blacksmith shop on Walnut Street had been at that location for many years when this photograph was taken. Pictured are Steve Pedrett (1) and Jim Moore (2). The Moores had previously forged many of the uniform pieces for the moorings on the foundations of Centennial Bridge.

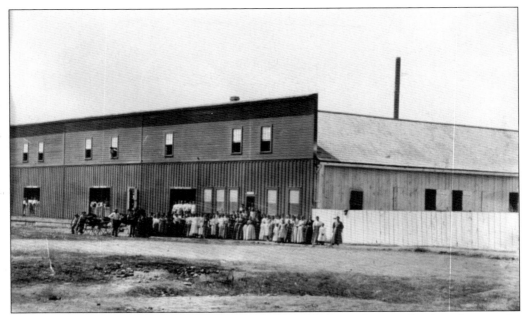

Sierra Lumber Company's building and new assembly plant is seen here at what later became the Diamond Match Company. This 1880s photograph is from an album in the collection of Belle (Shelton) Moulton.

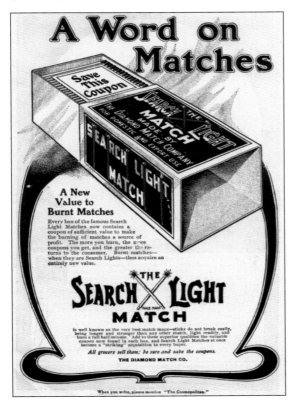

This 1903 advertisement is for Searchlight Matches. Diamond Match made "mini" matches approximately two inches long as well as matches 12 inches long. They were used as signal matches for their railroads that were first carried on the narrow-gauge tracks at Lyonsville.

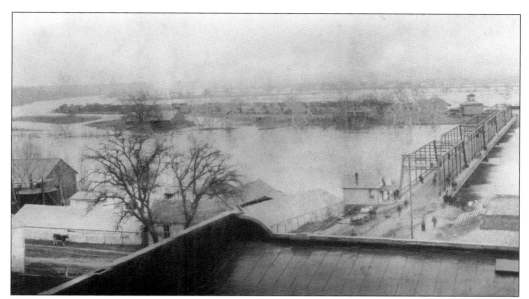

This 1884 view of the Sacramento River shows the raging waters that took half of Sierra Lumber Company's stockpile of timber down the river as well as many of their smaller buildings. The crew on the bridge is trying to keep it from washing away if the water rises. Note that there is no road at the other end of the bridge; it has already gone.

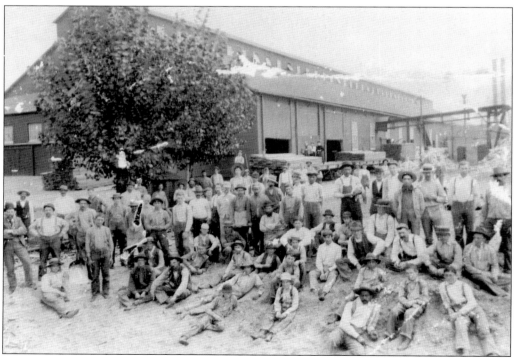

The Red Bluff division of the Sierra Flume and Lumber Company plant was built across the river from Red Bluff in 1877. This was the largest pine-board manufacturing plant in the world.

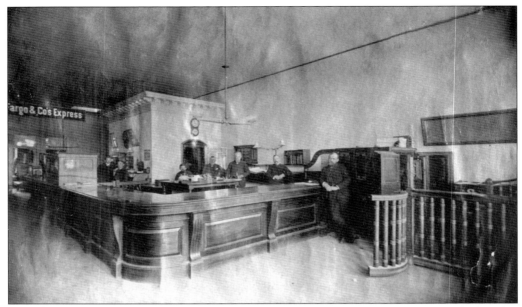

Wells Fargo and Company's express office operated out of at least two other locations before this building on Main Street. It shared space with the Bank of Tehama County (clearly visible on the vault). Security was a priority as Red Bluff was a stopping point in the middle of the route for people of all types going to and from the mines. Large amounts of gold were deposited for safekeeping overnight. Frank Walbridge was the agent.

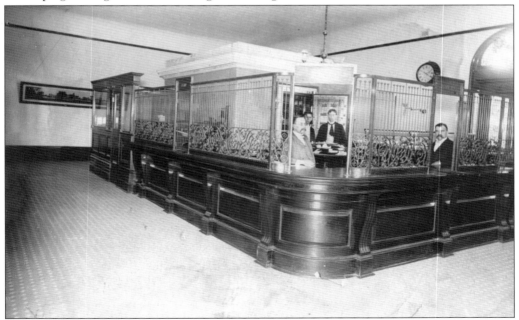

In this later photograph of the Bank of Tehama County, Wells Fargo and Company have already moved out and teller cages have been added along with other remodeling. E. B. Stanwood (left) and E. L. Gally attended the teller cages. The panoramic photograph on the wall is Red Bluff around 1898.

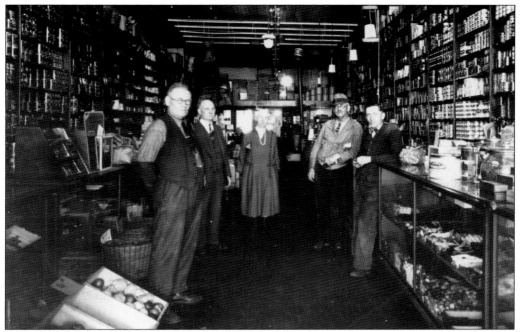

Red Bluff Mercantile was probably the most well stocked store on Main Street when this 1914 photograph was taken. A shopper could buy anything from penny candy to a new 14-karat gold pocket watch.

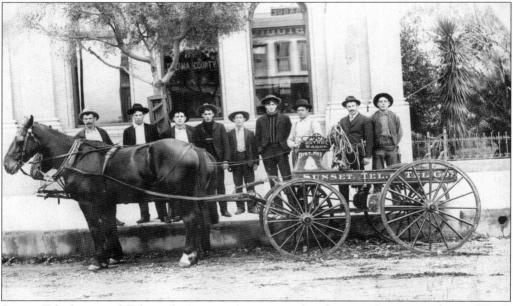

Sunset Telephone and Telegraph Company's crew stand with a patrol wagon in front of Bank of Tehama County in 1908. Work crews repaired lines, installed service, and did whatever was needed to keep service up and running. Note the heavy wooden guardrail around city trees to keep horses from chewing bark. The postal telegraph office was located in the downstairs corner of the Tremont Hotel.

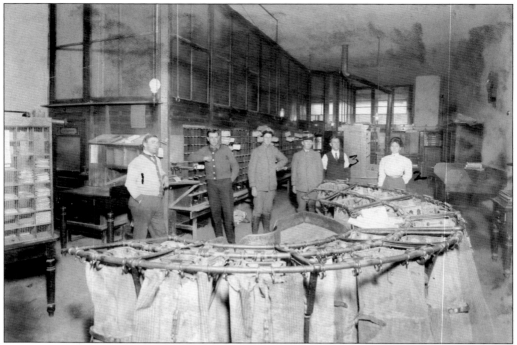

The new post office is pictured here c. 1915. By this time the post office was serving about 2,500 people and had a staff of six. Mail was sorted into the bags by area and then distributed.

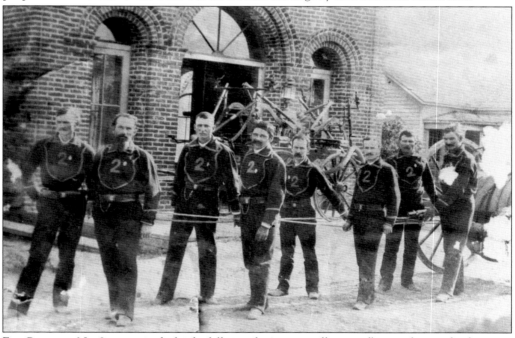

Fire Company No. 2, comprised of eight full-time firemen as well as standby members and volunteers, conducts exercises in front of its Red Bluff Firehouse No. 2. Equipment included horse-drawn and man-powered machines that could be more easily maneuvered into tighter quarters.

Red Bluff Fire Department Company No. 1 officers pose for this Gaines photograph at the turn of the 20th century. Red Bluff was proud of its horse and ladder company, and the firehouses were always well constructed.

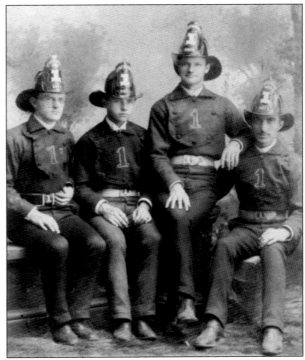

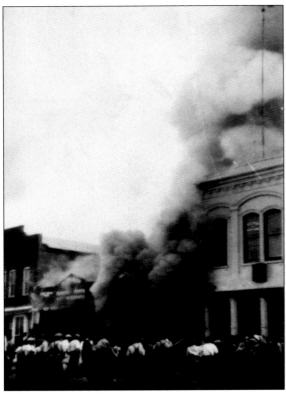

Fires have been a plague to Red Bluff since the beginning, but many of the buildings were of brick construction, and a good fire department always managed to keep fires contained and minimized damage.

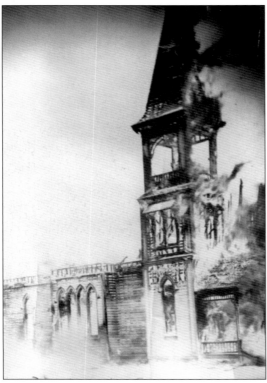

The Presbyterian church was one of Red Bluff's most beautiful wood-frame churches and was built with donations from parishioners. When it burned, many of the prized possessions were lost, including all the stained glass windows that were commissioned and made in San Francisco. The church was rebuilt.

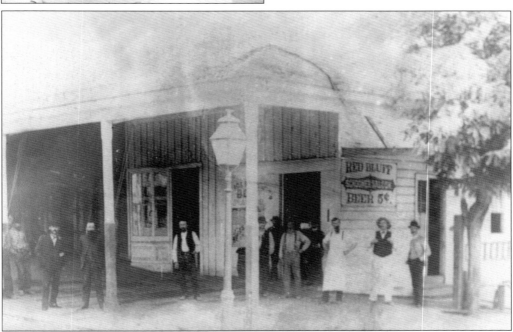

The Red Bluff Schooner Saloon was an early establishment that advertised beer for 5¢. It was lighted by gas, as were other businesses and some homes along several main streets. At its peak, Red Bluff boasted 32 saloons.

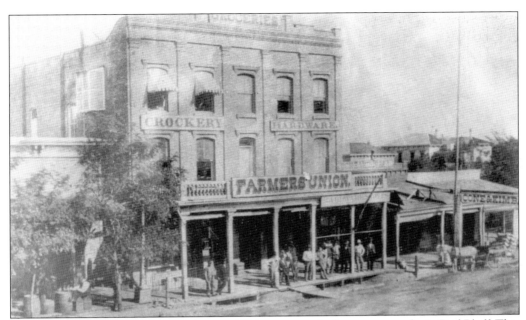

The Farmers Union Building, seen here in 1884, was an early day grocery outlet in Red Bluff. This store handled many larger items of machinery and farm equipment, and a Studebaker buggy or wagon could be ordered from their catalog. Note Cone and Kimball's humble store at right.

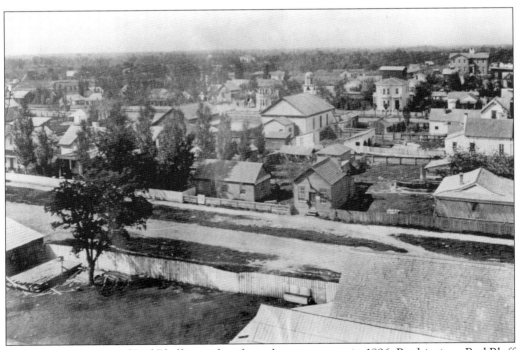

This panoramic view of Red Bluff was taken from the water tower in 1896. By this time, Red Bluff had grown to a sprawling community. Down the center of the image is "Mansion Row."

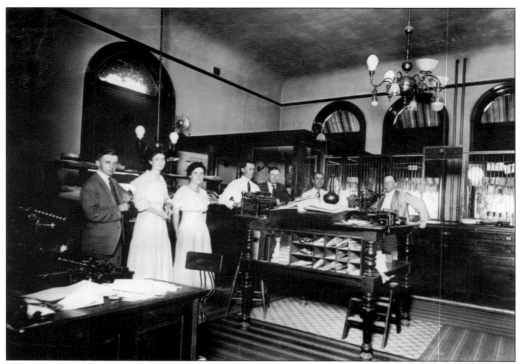

These two photographs from the collection of Walter Gosney show interior teller cages (above) and the office of the president of Tehama County Bank (below). Taken in 1913, the old gas light fixtures were altered when electricity was added.

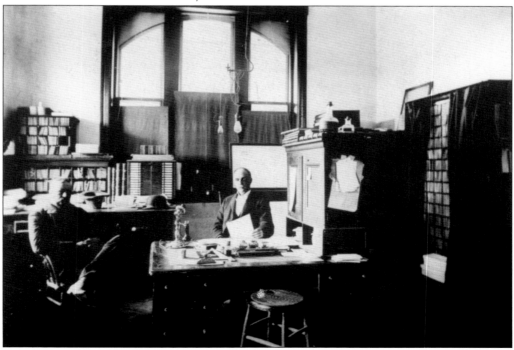

Three

EDUCATION AND LEISURE

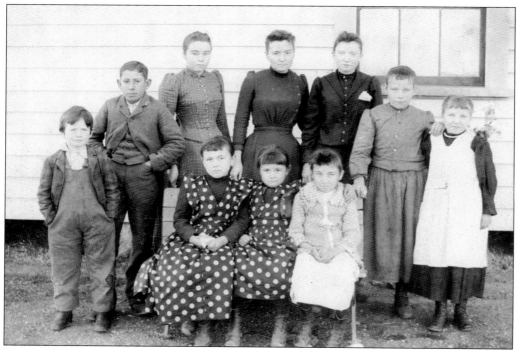

Huntsville School and some of its students are pictured here in 1884. The Stone sisters appear in the back row at right, and their cousin Eva Dunn is seated at right. Education was important to Red Bluff founders and citizens, many of whom had come from families with broad backgrounds and educations. The small one-room schools gave way to permanent towering structures built of stone, iron, brick, and wood.

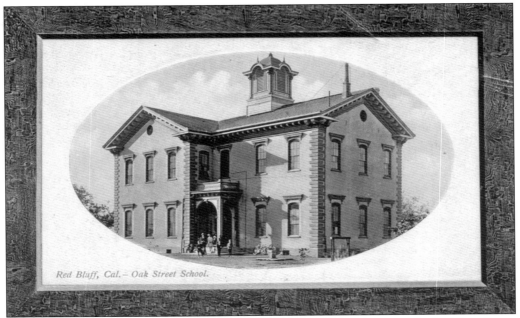

This 1900s photograph of the Oak Street School shows the permanence of the building. It was constructed out of brick made from clay in the red banks of the river. Pictured here is the 1898 honors class.

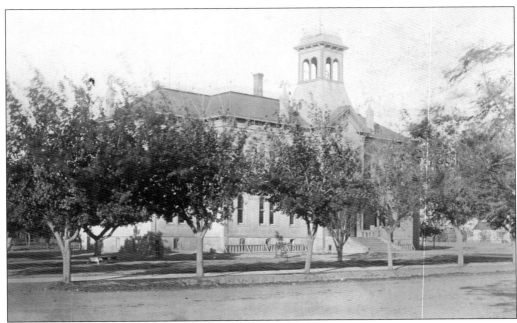

The old Lincoln Street School had two stories and a basement and a capacity for 300 to 400 persons. Many social events were held here in the early days, as it doubled as a community hall. One of the Red Bluff's most up-to-date buildings, it had its own furnace system. Note the iron widows walk on top.

RED BLUFF, CALIFORNIA.

June 15, 1905.

Following are your standings for that portion of the final examinations given at the end of the 8th year:

	STANDING.			PERFECT
Literature	Cr. 47	out of		50 Cr.
History	Cr. 36	out of		50 Cr.
Physiology	Cr. 44	out of		50 Cr.
Drawing	Cr. 45	out of		50 Cr.
Geography	Cr. 58	out of		75 Cr.

Very Truly Yours,

ELLEN A. LYNCH,

Secretary of Board of Education.

This 1905 report card was issued to Minie Azevedo on June 15 from Oak Street School.

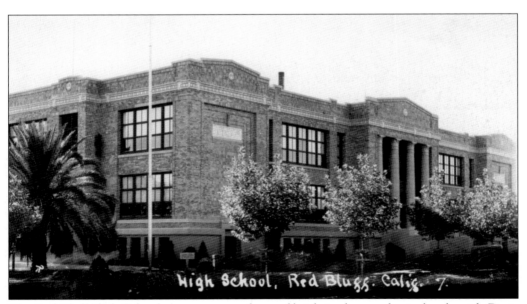

The Red Bluff High School was constructed out of brick in the neoclassical style with Doric columns and many brick and concrete adornments. A symbol of community pride, it has served the community well.

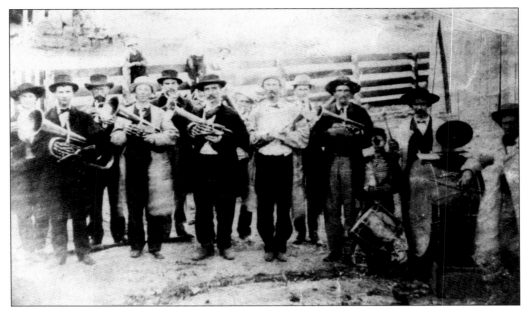

Red Bluff's first band is seen here around 1860. This is another Fourth of July view that was taken in the stock pen just beyond the town square (background). The boy with the small drum is not a child at all but the "town midget" whose name was Cly Pearson.

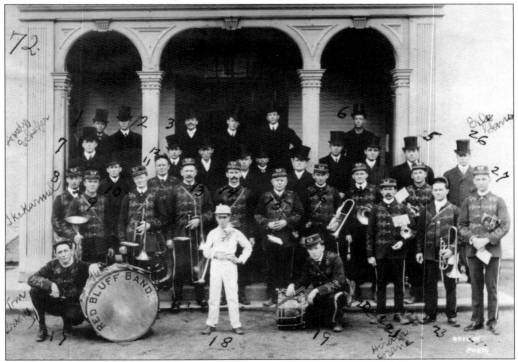

The Red Bluff Band, pictured here in 1884, had its own monogrammed uniforms. Many people in early Red Bluff, as in other places, played instruments if for no other reason than to while away the long evenings.

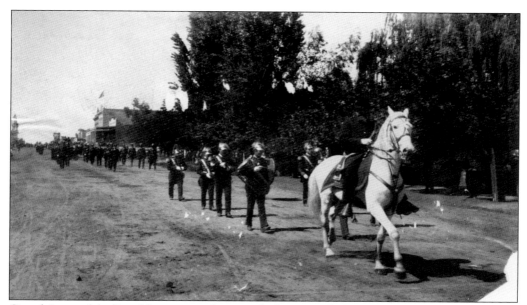

Grand Army of the Republic reunions happened often in Red Bluff. Here is a group that gathered at a Red Bluff picnic in 1867. Many are unidentified, but Ed Drane (carrying a tuba), Frank Drane (on the left behind him), and Bert Hughes (on the horse) have been identified. Corresponding lists of names have long been lost.

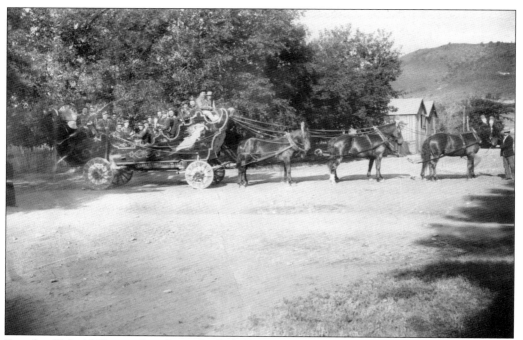

Fourth of July 1897 was a hot day in Red Bluff, and this parade ended up across the river on the Gurnsey place. Here the Red Bluff Band has gotten a ride after marching. (From Alice Olson Pitt's album; courtesy H. S. Dorothy.)

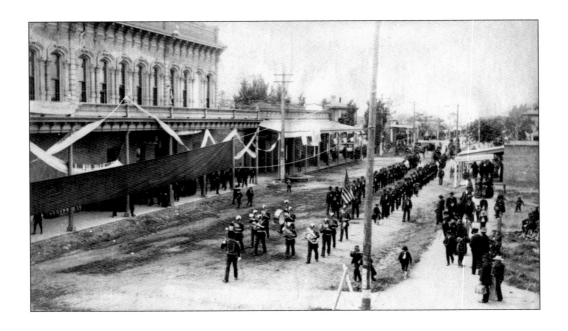

This Armistice Day parade depicts Main Street in 1912. Red Bluff's citizens were very patriotic when it came to parades and civic events, and the turnout for these events was always good.

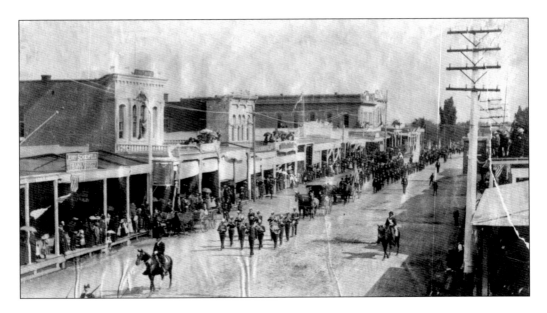

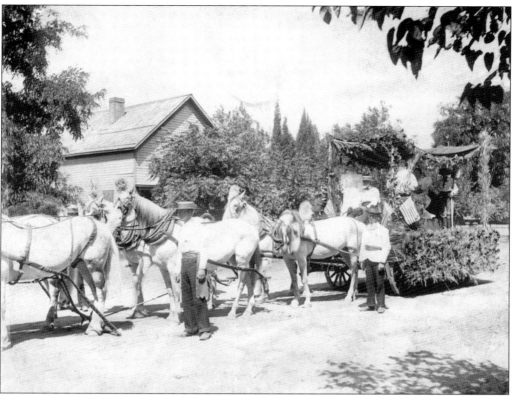

The 1909 Women's Improvement Club float, seen above on the Fourth of July 1897, was pulled by eight white horses with plumes as the parade winds down across the river. Uniforms for the Red Bluff Band changed from year to year. This photograph at right shows them in their best dress uniform. (Above courtesy H. S. Dorothy.)

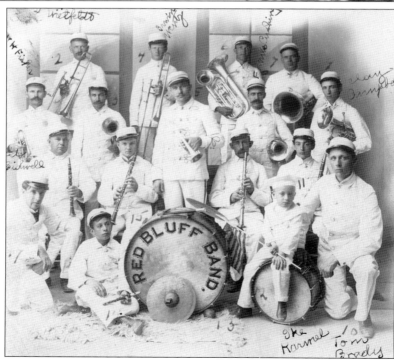

The Red Bluff Ladies Clubs got together to do much civic improvement. In 1881, many of them assembled to make cards for each other to commemorate their activities. This card belonged to Jennie Payne (back row with hat).

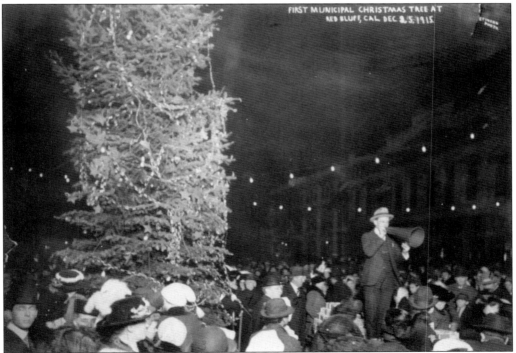

This image captures the first municipal Christmas tree, the beginning of a long ongoing tradition in Red Bluff. The event turned into an annual gathering and dinner where people would bring their supper and exchange gifts.

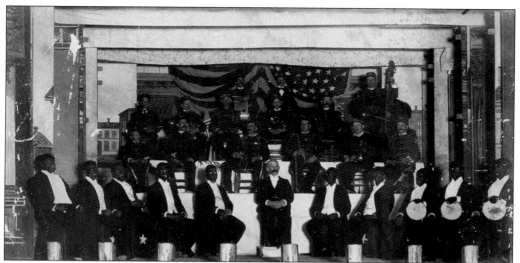

The Masons and Odd Fellows are seen here joining forces with Civil War veterans. Each group had its own band, exclusive of the Red Bluff Band. Here they practice for a "spoof" play of *Uncle Tom's Cabin*.

Tom McClure and his dog are on an outing at the upper end of Oak Hill. In the early days of Red Bluff, it was planned that Oak Hill should be a park, but in the end the cemetery expanded and many of the large oaks were cut down.

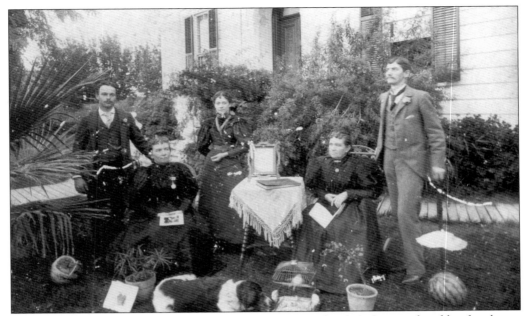

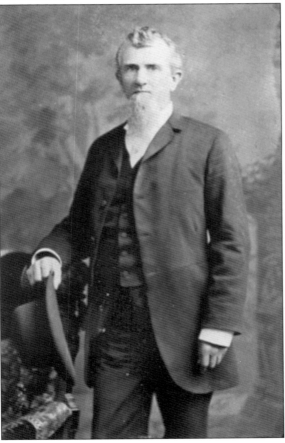

Judge C. P. Braynard and his family are seen here in their yard on "Mansion Row," as the citizens referred to it. Mrs. Braynard was active socially in the early days of Red Bluff and gave heavily to church building funds and the community. Braynard is also pictured at left.

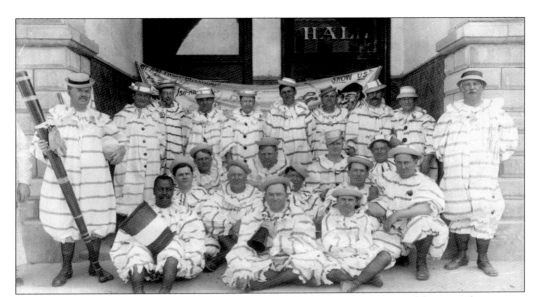

The exuberant Redmens Club, part of a national organization, started here with a group of businessmen and was a novelty in the early days of the city. Redmen in hijinks costumes provided comic relief, marched in parades, entertained townspeople, and donated money for civic improvements. Redmen, descended from Missourians who settled on Missouri Hill in Red Bluff, display their banner, "We are from Missouri. Show Us."

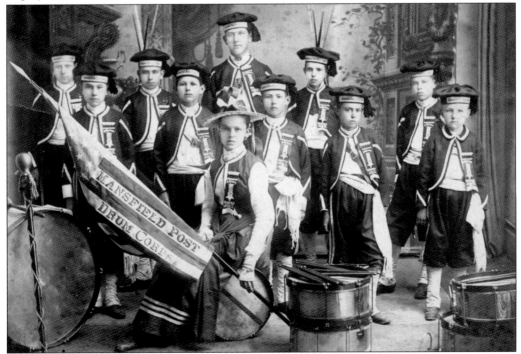

Mansfield Post Drum Corps was organized in 1864 as a forerunner to the Boy Scouts or 4-H. This was probably a means to help keep children off the streets. This photograph was probably taken before 1870, though little is known about it. (Miranda Parsons collection, courtesy William Gurnsey).

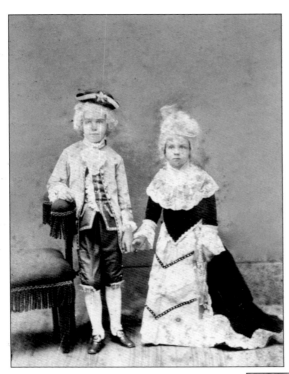

Jamie Cameron and Mattie Schroeder (both children of local business owners) celebrate the Fourth of July 1880 in a school play at the town picnic.

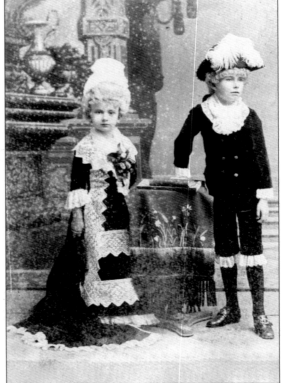

Here are George Puls and Blanche Clements posing after the Fourth of July parade in 1880. There was also a play that evening at the opera house called *Founders of Our Country*, in which George and Blanche played George and Martha Washington.

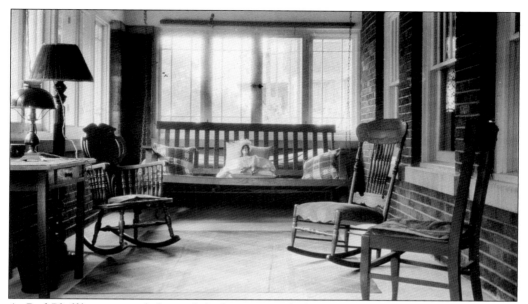

As Red Bluff became settled, people had more time for leisure. Open porches were enclosed for evening entertaining. Here is the McClure home porch in 1922 across the river on the Gurnsey Avenue annex.

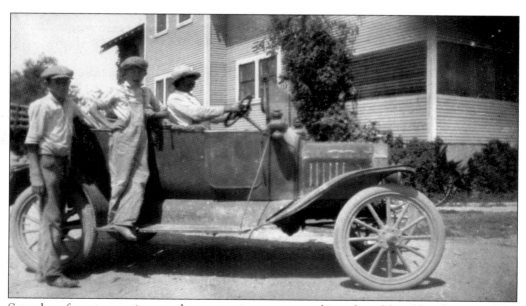

Saturday afternoon outings to the mountains were something shared by old and young alike. Here John Chapman and sons Charlie (left) and John prepare to leave for a fishing day trip up the Hogsback Road to Antelope Creek. This photograph is marked July 18, 1928.

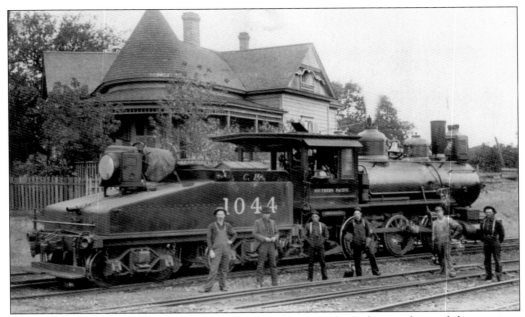

The roundhouse (stationmaster's house) in Red Bluff sat just above the switches and the terminus of the tracks. Here SP Engine No. 1044 and crew are preparing to back out to another siding and hook up to a train around 1899. The train had its own reservoir and firefighting equipment.

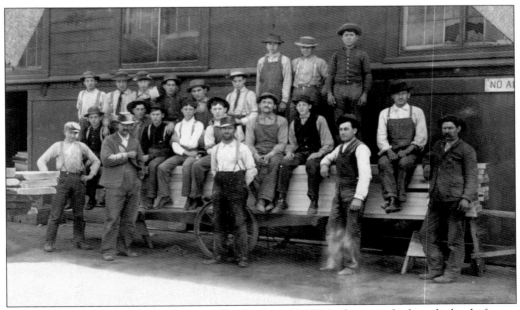

Diamond Match factory employees pose for this June 14, 1909, photograph aboard a load of sugar pine stock used to make millions of matches. The Diamond Match Company took over the Sierra Lumber Company.

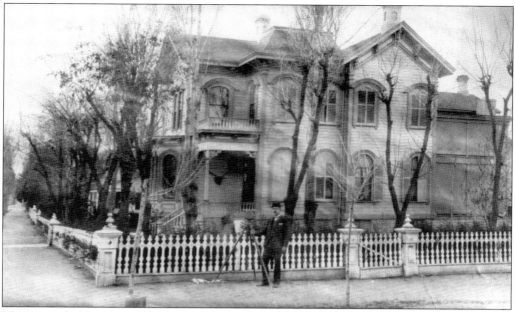

Many stately Victorian homes graced the streets of Red Bluff. This one on Ash Street is unidentified but was brought in from Eureka and assembled in the 1880s of solid redwood, including the fence.

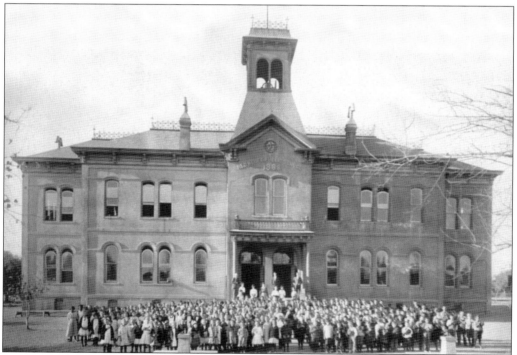

In 1894, this photograph of students at the Red Bluff Public School included eight grades. This imposing structure, built in 1884, had a seating capacity of over 500. Classes were held in the basement in the summer to escape the heat.

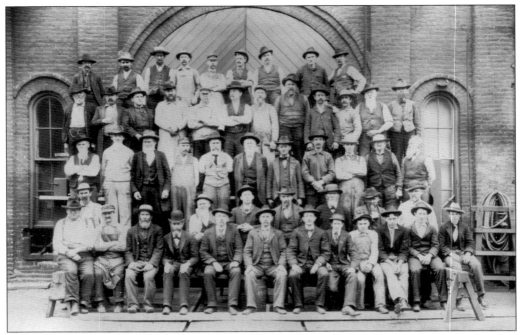

The maintenance crew, pictured here in 1902 on makeshift bleachers at the Sierra Lumber Company (later Diamond Match) yard, sit in front of the engine house. Train tracks led into this building so that whole train engines could be worked on

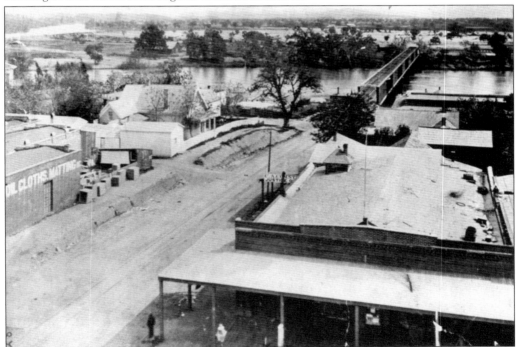

Taken from the water tower, this view across the river depicts Sierra Lumber Company's plant as well as Huntsville at the far back right of the photograph.

George and Carrie Kingsley constructed Red Bluff's Kingsley's Opera house, which featured plush carpets, chandeliers, and velvet seats and curtains. The color scheme was burgundy and gold.

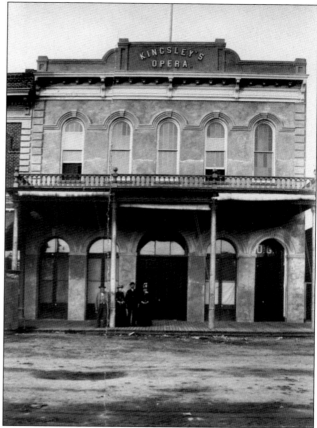

The Tremont Hotel with its Ionic columns is seen here around 1928 in a postcard intended for mailing. It also shows the Cone Kimball Tower and Bank of Tehama County.

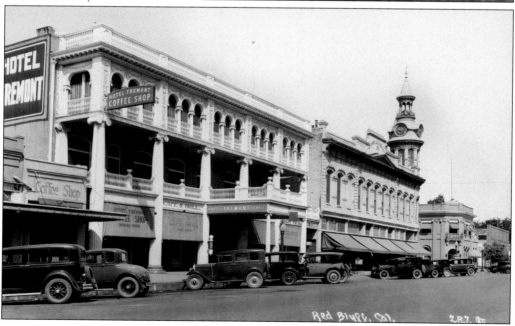

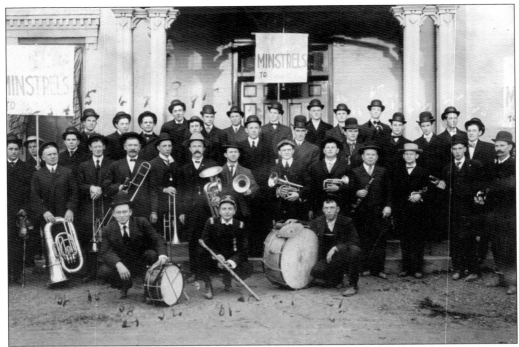

Red Bluff Minstrels had their own band when this photograph was taken in 1906. The Minstrels was a short-lived group and their names are unknown.

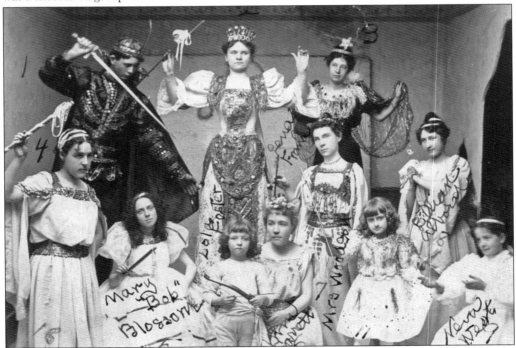

This play was held on the stage of Kingsley's Opera house by a group of locals called the Daffodils. (Courtesy Woodson album).

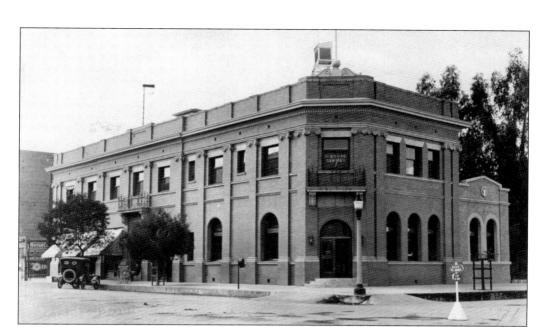

The Bank of Tehama County was a well-built structure that sat on Main Street across from the Cone and Kimball Building. Constructed in the 1920s, it became known as a popular spot for people to meet at noon to transact business and go to lunch.

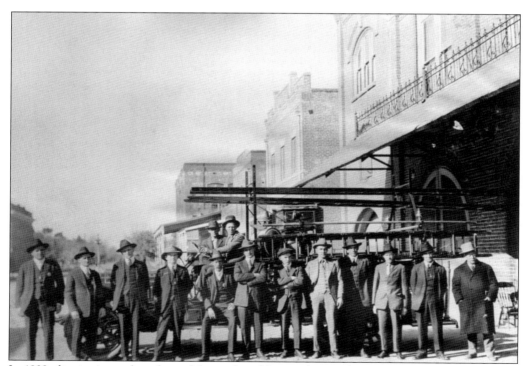

In 1932, dignitaries gathered to celebrate the addition of a new fire truck. Pictured here in front of the old firehouse are members of the city council and county supervisors.

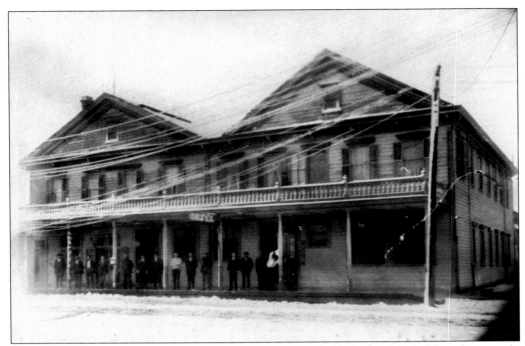

The old Concordia Hotel and its outbuildings comprised half of a city block. This photograph, taken in 1912, shows a snowy day with patrons lined up on the porch.

This side view of the Concordia Hotel shows the builder's house, water tower, and stables. This side lot was used as a garden to supply the dining room with vegetables.

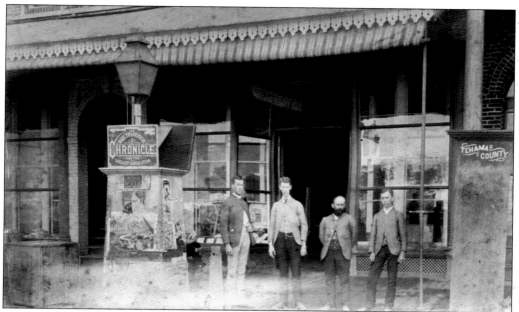

John Clements, seen here with a beard, poses around 1885 in front of the post office, which was housed in part of the Clements store. The other three men, from left to right, are Will Lewis, Warren Woodson Sr., John Clements, and R. Charles Hughes, a teacher at R. B. Union High School.

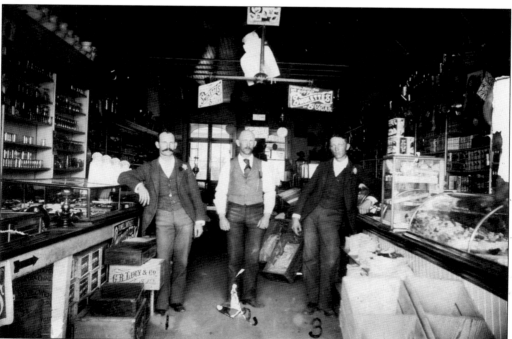

This is a view of Albert Fuller's first store. Pictured, from left to right, are Bud Brady, Albert Fuller, and W. H. Fisher as they pose amid cramped quarters. Shortly after this photograph was taken, Fisher expanded to his larger store. He was one of Red Bluff's most successful businessmen.

In 1914, Walter Gosney and John Gibson brought a used Ford Touring car and converted it into a hunting guide service. Taking clients from San Francisco and Southern California, it proved to be very successful. On the back of the postcard was the message above right. One such excursion in 1919 took angler E. C. Powell (a cousin of both men) to Averys in Mill Creek Canyon where he showed his expertise with an eight-foot split bamboo pole and Powell flies. The hunting guide service ran until 1922.

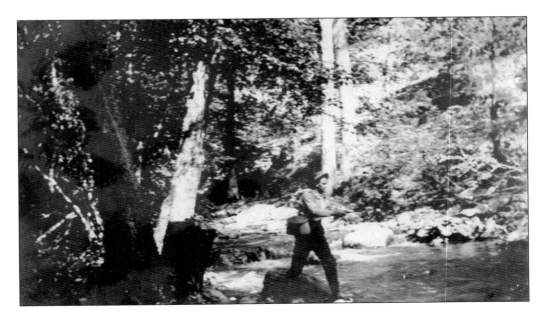

Four

WHO WE WERE
THE PIONEERS

The founder of the Woman's Improvement Club, Sarah Jane Knauss (seated), is flanked, from left to right, by Belle Moulton, Annie Westrope Shelton, and Alice Olson at one of their early meetings in 1901. Mrs. Knauss was a large landowner on the southeast Hogsback Road. The club became very popular and often hosted green and white teas (where everyone dressed in white and the gardens where the teas were held were green).

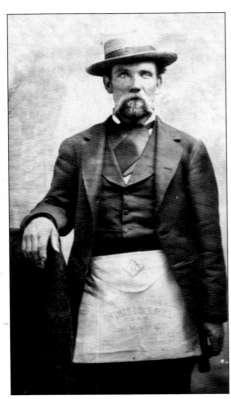

Dan Hull, father of Sheriff Lloyd Hull, was one of the original Masons who came to Red Bluff in the 1850s. The apron reads, "Newville Lodge No. 205 F. & A.M. Daniel Mosier Hull." Hull was a founding pioneer of Newville with the Finnel and James families.

James Alexander Shelton, active in both Red Bluff and Newville, promoted river commerce and Thoroughbred racehorses and had a racetrack on his extensive ranch. He first crossed the Plains with his two brothers and landed at Hangtown, later renamed Placerville, in 1849. Returning to Iowa, he came back to California in the 1860s, eventually owning 23,000 acres in Newville and Red Bluff. The Blue Mare, a horse that ran in the famous Virginia City race, was one of his prized possessions and netted purses totaling $700,000.

John James owned part of a shipping company, the James Ranch in Newville, and several farms in conjunction with William Gurnsey. Known around Red Bluff as "Crazy John," he always carried a stick or riding crop and on several occasions used them to beat people. James vehemently disapproved of his son-in-law's racehorses that often took him away from his ranch and family. John James lived at Paskenta when this photograph was taken.

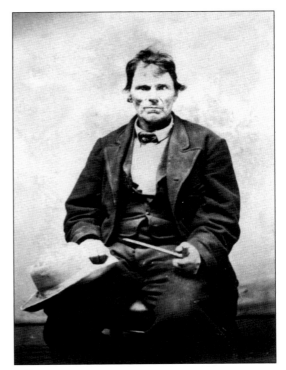

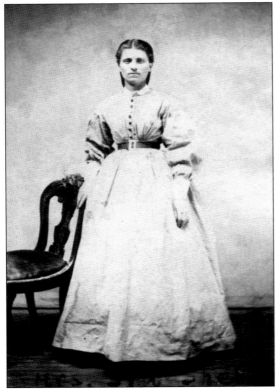

Jennie T. James, daughter of John James, married James Alexander Shelton. Jennie traveled extensively and entertained lavishly at her home, playing hostess for many dignitaries at the Shelton ranches in Red Bluff and Newville. Her portrait was commissioned by her father and painted by Sacramento, California, artist John Jurrist. The portrait remains in the family.

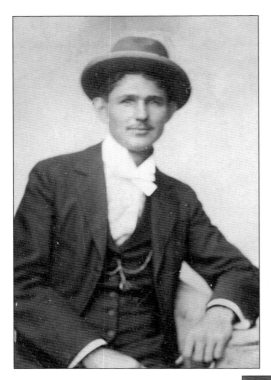

Ed Stockton came to Red Bluff in the 1860s. He had worked previously as a riverboat hand. Stockton, a dandy and a gambler, was often seen in saloons and in the company of attractive woman. The town of Stockton was named after Ed's parents.

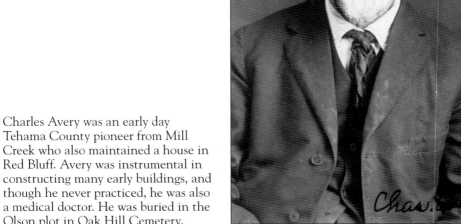

Charles Avery was an early day Tehama County pioneer from Mill Creek who also maintained a house in Red Bluff. Avery was instrumental in constructing many early buildings, and though he never practiced, he was also a medical doctor. He was buried in the Olson plot in Oak Hill Cemetery.

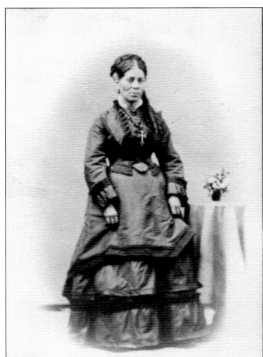
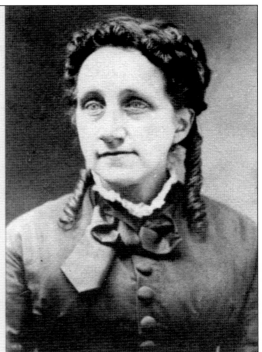

Jane Thomes, sister of R. H. Thomes, was born in 1807 in
Cumberland Maine. In 1852, her brother Robert in Tehama
County sent for her, and she set about keeping house and
cooking for him until he died in 1878. She passed on in
1882, although no birth or death dates are recorded.
She was one of the many heirs to R. H. Thomes's
estate and is often misrepresented as his wife. The
Tehama Cemetery District maintains her plot and
family information.

Robert Hasty Thomes was born on June 16,
1817, in Cumberland, Maine. He originally
came to California in 1841, and in 1842, he built
a hide-storage business with Bryant and Sturgis of
Sacramento City. He came to Tehama County in
1845 with his lifelong friend A. G. Toomes. Thomes's
Mexican land grant was along the Sacramento River.
When he was awarded the grant he stated, "Here is my
ranch, here is where I will live and die." Thomes deeded
the Tehama Cemetery land. He died on March 26, 1878,
at his ranch.

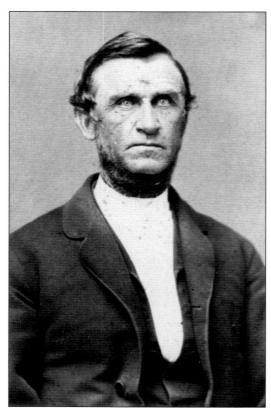

At left is John McCoy, father of A. M. and Leo McCoy. He came from Carthage, Illinois, where he was instrumental in the development of the Mormon Church. He moved from Salt Lake to Red Bluff in 1872. The McCoy family (below) was in Tehama County as early as 1865, investing in stock and land, and owned partial interest in several businesses.

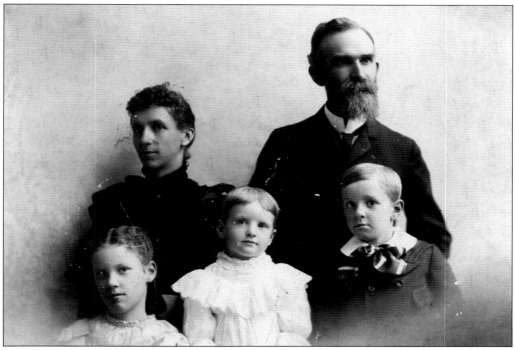

Business and ranch owner Warren K. Woodson crossed the Plains when he was 18 years old in 1868. He was appointed Red Bluff postmaster in 1886. The Woodson Bridge on the Sacramento River is named after him. Along with his wife, he was one of the promoters of many civic plays and activities.

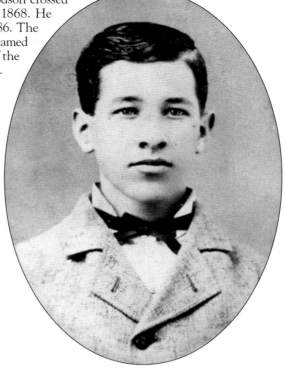

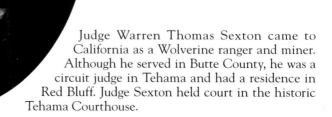

Judge Warren Thomas Sexton came to California as a Wolverine ranger and miner. Although he served in Butte County, he was a circuit judge in Tehama and had a residence in Red Bluff. Judge Sexton held court in the historic Tehama Courthouse.

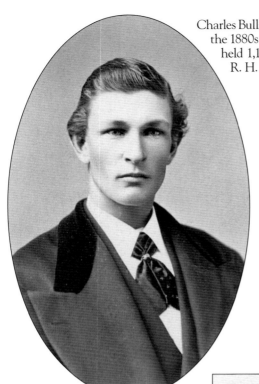

Charles Bullard was a successful farmer who came to Red Bluff in the 1880s and bought land to the west of town. He eventually held 1,100 acres and purchased 400 additional acres from R. H. Thomes.

Edna Bullard was one of the founding members of the Red Bluff Garden Club. The Bullards lived in a gracious Victorian in which they often entertained.

An early businessman who came to Red Bluff in 1880, George Kingsley is best known for the discovery of Kingsley Cave in Mill Creek Canyon, where the great slaughter of the Mill Creek Indians took place. Kingsley was visiting a friend, Charles Avery, when he happened upon the inhabited cave and reported his find when he returned to Red Bluff. Kingsley, who also owned the opera house in Red Bluff, lived at the corner of Main and Elm Streets. He was engaged in the business of manufacturing buckskin gloves.

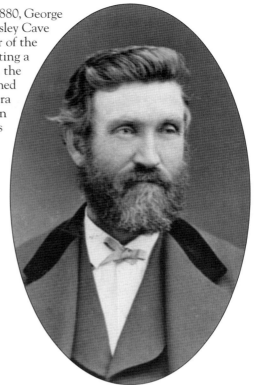

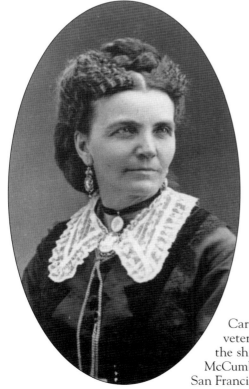

Carrie Weston Kingsley was the granddaughter of a veteran of the War of 1812. She was an argonaut on the ship *Euphrasia* in 1849 with her first husband, John McCumber. After his death, she came around the Horn to San Francisco, met Kingsley, and married him.

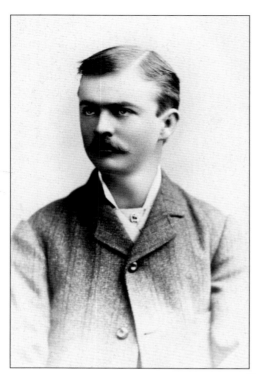

Ancil Brown served several terms as treasurer of Tehama County. Born in 1862 at Newville, he mined in Alaska and returned to Red Bluff after the death of his father. In 1892, he was also a bookkeeper for the Sierra Lumber Company and owned the post office building and a large ranch.

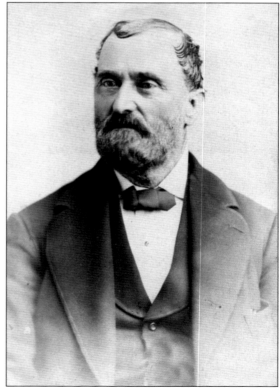

Henry W. Brown, the father of Ancil Brown, came to California's Feather River in 1850 searching for gold. In 1858, he moved to Newville, in Tehama County, and was active in public affairs, served as postmaster, and owned 20,000 acres.

Elias Gardner was president of the Red Bluff Chamber of Commerce. He was partially responsible for the evolution of a "new Red Bluff," from shacks to attractive homes. He laid out the Sunnyside addition and owned many private lots, which he sold to others.

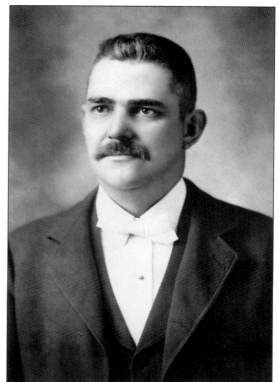

Douglas Spencer Cone, the son of Joseph S. Cone, attended school in San Francisco. Although his mother and sister took over the management of the family estate after the death of his father, Douglas remained active until his death.

A. J. Bogard, Tehama County sheriff, poses here in 1865. Born in 1848, he came west to Red Bluff with his family in a wagon train from Missouri in 1861. He succeeded his brother as sheriff after his brother was murdered on a train by robbers. Bogard hunted down the killer and had him put in prison for life.

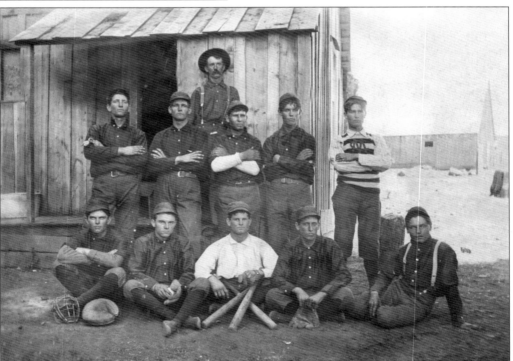

This Huntsville baseball team, whose members are unidentified, was photographed in 1899, across the river from Red Bluff where the Sierra Lumber Company buildings would eventually stand.

John Grimes was a produce steward on the riverboat *Delta Queen* who settled in Red Bluff and became a deputy sheriff. (Photograph by Reinhart.)

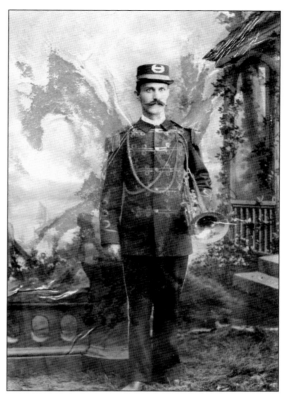

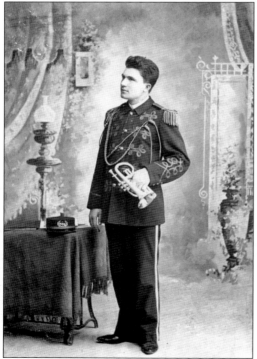

John Durand is seen here in 1892 as a member of the first Red Bluff Band when he was 22 years old. He originally joined that group at age eight and continued to play trumpet and trombone in the band until he was in his 50s.

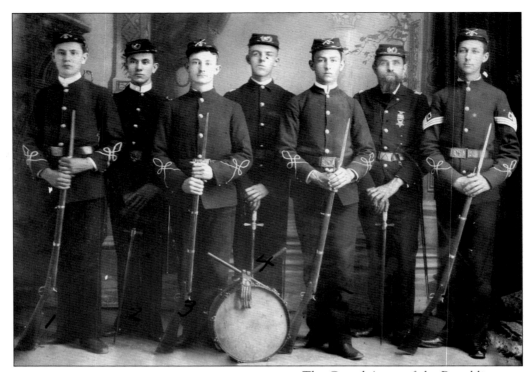

The Grand Army of the Republic held reunions with members and their succeeding generations who would become members. John Drane (6), who conducted with a sword, poses with his son Ed Drane (2) and cousin Frank Gilson (7).

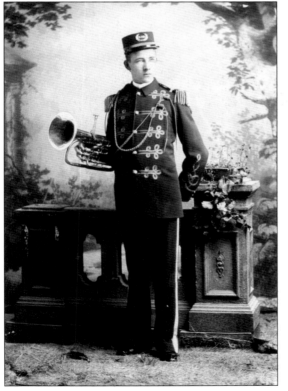

John Tucker, seen here in 1899, was one of the Red Bluff band members who remained in the original band until it disbanded 32 years later. The band was later reorganized.

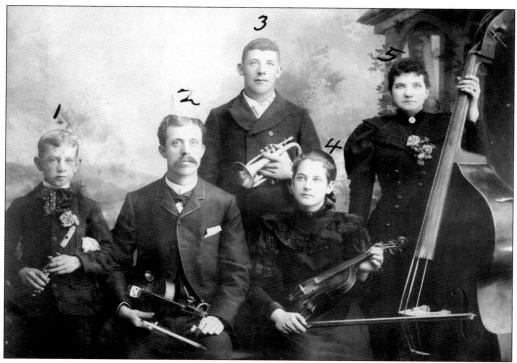

Henry Trask and his wife, Emma, often performed with his Trask family band, pictured above. His children and bandmates are Edmund (left), Emma (seated), and Charles (standing center). Seen in the photograph at right, Edmund Trask became a member of the Red Bluff Band many years later, after his family stopped performing as a group.

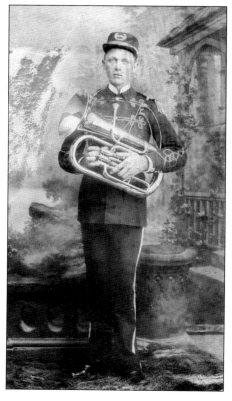

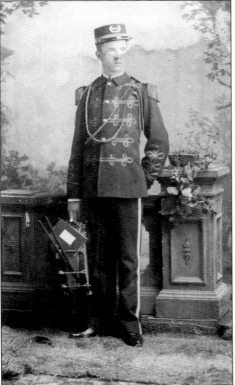

The image above comes from a tintype of Benjamin Alford shortly after he arrived in Red Bluff in 1868 at age eight. The photograph below shows Benjamin at age 38 dressed in his Red Bluff Band uniform in 1898.

Simpson Freeman was born in Springfield, Illinois, on January 2, 1862, and came west when he was 22. At 24, he owned a home in Red Bluff and was a circuit (substitute) teacher for the Lake and Antelope school districts.

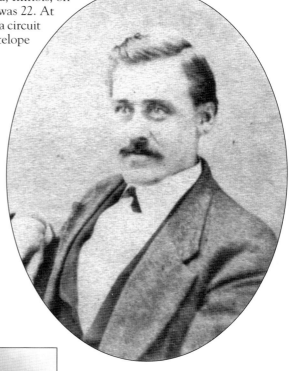

Henry Jerome Banks, an early leader of the Odd Fellows in Red Bluff, was very active socially and lived in a lavish brick mansion. He dealt in land trades and owned much timberland above the valley floor and many water rights for flumes and ditches.

Minnie Gilmore, seen above, was the first wife of Frank Gilmore. The Gilmores were already very affluent when this tintype was made in 1863. She died while still a young woman at 34. Frank Gilmore, below, was a striking figure who played a large role in early Red Bluff. He actively acquired timber and shipped lumber to St. Johns or Monroeville and on to Sacramento City.

Mathew Ward was the son of a preacher and was very active in the IOOF (Odd Fellows) lodge and in raising funds when the original Odd Fellows building was destroyed by fire.

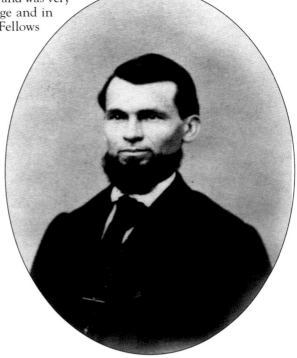

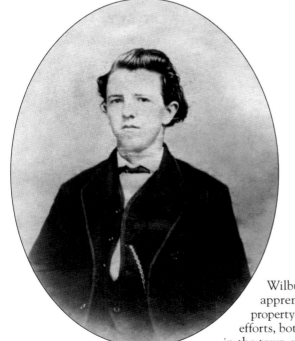

Wilbur Townsend was 22 when asked to be an apprentice to surveyor James DeHaven. Many property lines were finalized as a result of Townsend's efforts, both on outlying ranches and farms as well as in the town of Red Bluff.

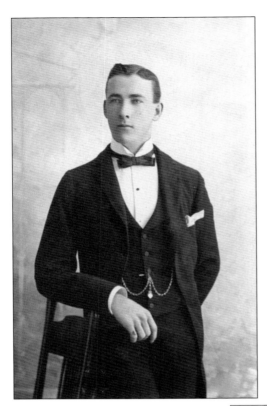

Clay D. Campbell of Red Bluff worked as a boy doing cleanup at the Schooner Saloon. He was taken under the wing of John Grimes, who put him through Chico Normal School. Clay spent lots of time in Sacramento and gambled aboard various riverboats. He must have been a proficient gambler because between trips back to Red Bluff he lived a polished and refined life in Sacramento as seen in this 1886 photograph.

Bert Kuhn was an early personage around Red Bluff. First working for Mayor John Brady as a stable boy, he spent time aboard the *Dixie Queen* as the ship's carpenter. Kuhn later made fancy woodwork for Red Bluff's finest homes.

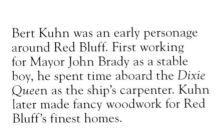

C. G. Crandall came to Red Bluff from Enterprise in Butte County near Bidwell Bar. The Crandall family originated in Crane Dale, England, and came to Westerly, Rhode Island, in 1638. He was involved in freight and shipping and became very wealthy. His brother was Henry Crandall, who started the New York City School for the Deaf.

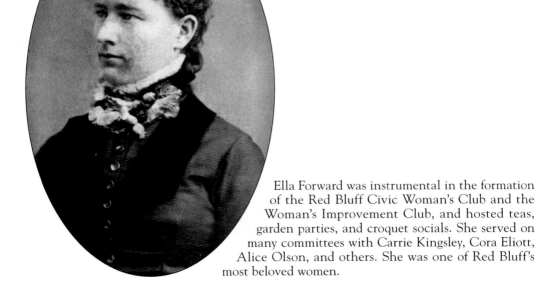

Ella Forward was instrumental in the formation of the Red Bluff Civic Woman's Club and the Woman's Improvement Club, and hosted teas, garden parties, and croquet socials. She served on many committees with Carrie Kingsley, Cora Eliott, Alice Olson, and others. She was one of Red Bluff's most beloved women.

E. F. Lennon came to Red Bluff with his wife, Katherine, in 1868. Married in 1858, he mined the Middle Fork channel on the Feather River from 1860 to 1868 with great success and put profits into a freighting business that ran from Red Bluff to Honey Lake.

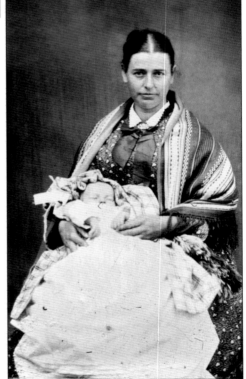

Before E. F. Lennon left for a two-year stint at the mines, his wife, Katherine, left behind in San Francisco, had this tintype made for him. Lennon was a gold miner on the Middle Fork of the Feather River. Tintypes were popular because they transported easily in pockets, but they were expensive at 25¢ each.

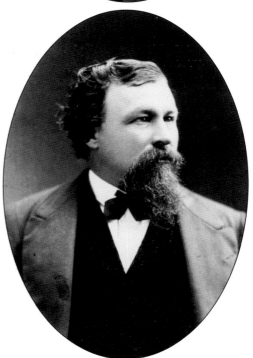

The Gouch Brothers were influential figures around Red Bluff. Jim Gouch (above), the eldest, possessed a shrewd sense for business and pooled his fortune with his brother's to acquire the famous 11,000-acre Blossom Ranch. Jim Gouch's brother Jack (below) often lived the high life in San Francisco where this cabinet card was taken in 1888.

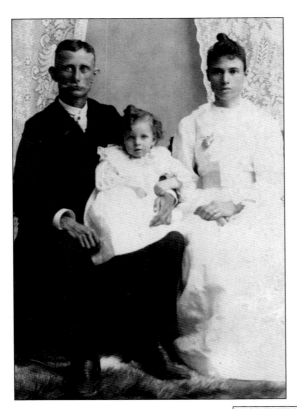

Wesley Clement Hickman, born in 1861 in Michigan, became foreman of the Red Bluff and Antelope Water Company. He lived in a very nice home on Jackson Street.

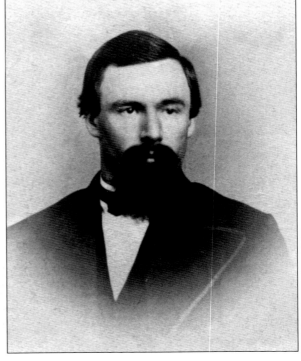

Darwin B. Lyons's father came to Red Bluff in 1859 and ran the Sierra Lumber Company. The town of Lyonsville is named after him. He owned a half interest in the firm of Lyon and Garret on Main Street. He died at his home on Ash and Washington Streets on September 5, 1902.

Olen Vestal (above) was one of nine children born to Thomas Vestal of Yuba City. Olen came to Red Bluff around 1872 and became active in affairs of the town. He and his wife (below in 1876) operated a dry goods store on Main Street. They were married in 1874. Maud was active in the Red Bluff Garden Club, worked with her husband in the dry goods store, and was well known in Red Bluff for her fancy dresses.

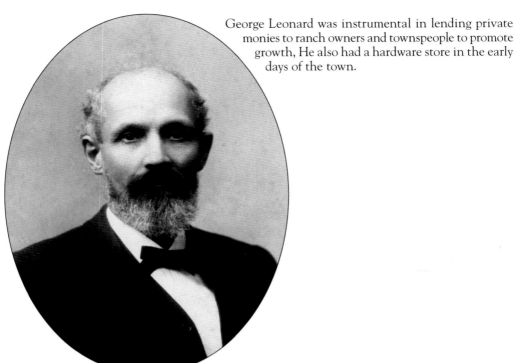

George Leonard was instrumental in lending private monies to ranch owners and townspeople to promote growth, He also had a hardware store in the early days of the town.

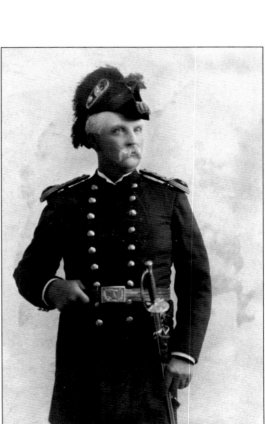

Major G. H. Ward was a notable character around Red Bluff in the 1880s and could often be seen in his uniform parading the streets by himself.

Robert Rosereve was a friend and business partner of Warren Woodson. On the back of the photograph, taken in 1886, is written, "Robt who wrote that part of the J. S. Lewis history of the first survivors of the massacre?" J. S. Lewis wrote of the Three Knolls Village Massacre in his 1890s history.

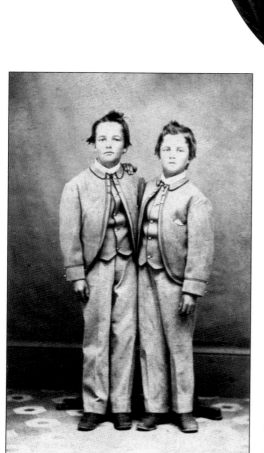

W. F. and Tom Brooks were born in Red Bluff in 1862 and are pictured here in an early census of Tehama County. W. F. and Tom were listed as ranchers in Antelope. Their parents originally settled at Gurnsey Creek.

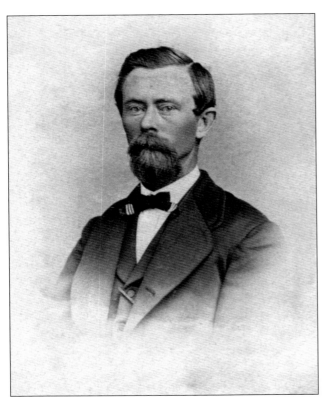

George F. Morris Jr. came to Red Bluff in 1868. He had worked previously as a miner at Missouri Bar on the North Fork of the Feather River. With proceeds from mining, he bought 80 acres from R. H. Thomes and eventually became foreman of the Thomes holdings near Tehama after Thomes's death.

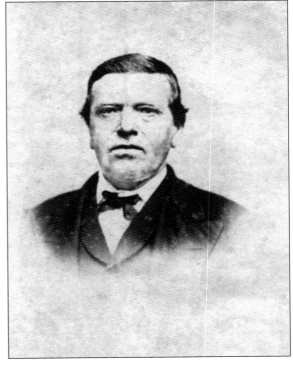

David Lawrence Stew lived in, for much of his life, in rented rooms at the best hotels in Red Bluff. Stew was often seen at the Newville racetrack betting on horses. He eventually relocated to Newville from Red Bluff, but the town was dying out by that time.

Joseph Smith was born in Missouri and came west in 1862, settling at Stonyville near Newville and joining the Newville Lodge. He later moved to Red Bluff. He was a member of the Masonic Lodge in Red Bluff and painted murals on the inside of the Masonic temple.

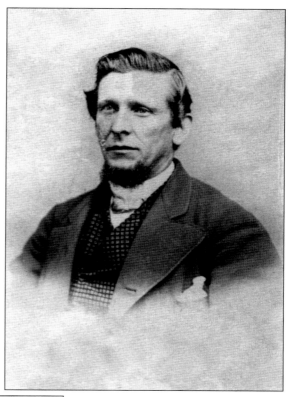

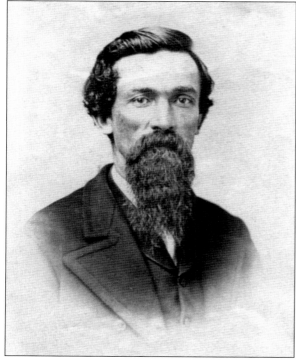

Milton Chandler, a Native Son of the Golden West as William Ide called him, was a cousin to Sarah Brown Cooper Ide. Chandler was a neighbor of James Fenimore Cooper, the poet, in Missouri before coming to Red Bluff. Though Chandler claimed to be one of the first immigrants to inhabit Tehama County, no definite dates exist.

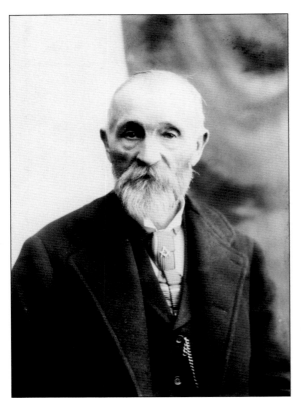

William Boatman was 76 years old when this photograph was taken in 1896. A Red Bluff farmer and dairyman with extensive landholdings, Boatman was a 32nd Degree Mason and had acquired most of those degrees at Newville and Red Bluff lodges.

James W. Boatman was 15 years old when this photograph was taken in 1877 in San Francisco. By then, James was helping his father, William, with chores at their Newville and Red Bluff properties.

Five

THE ORIGINAL
VALLEY DWELLERS

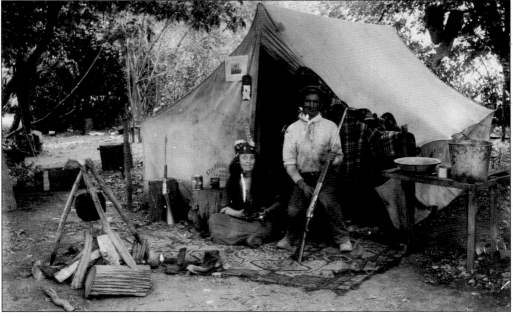

During the 19th century settlement era, Native American attacks were always a concern in Red Bluff. The large oak forest that topped Oak Hill and Oak Flats had been inhabited for centuries by the Southern Yana. During the town's early years, there were periodic skirmishes with the area's original settlers, the Native Americans. Where Oak Hill Cemetery is today, large rocks were removed that had mortar holes pounded into them to grind the acorns of the forest into flour. Then it was cooked into mush or acorn cakes, a staple of the valley people. This campoodie extended clear across the ridge to Second Street, where other mortars were found in yards of newly built homes from the 1860s to 1880s. Driven further out or forced to become domestic servants or ranch hands, often unpaid, some Native Americans chose to become renegades, striking back by raiding cabins, stealing cattle, killing settlers, and ransacking. Others joined a type of society that adopted Caucasian dress and manners and tried to fit in. This image shows Madison V. Shelton, in later years, visiting the camp of Emma, also known as Red Wing, the daughter of Hannah Gurnsey Gray. This camp was in Mill Creek Canyon. The Shelton's divorced in Red Bluff in 1903.

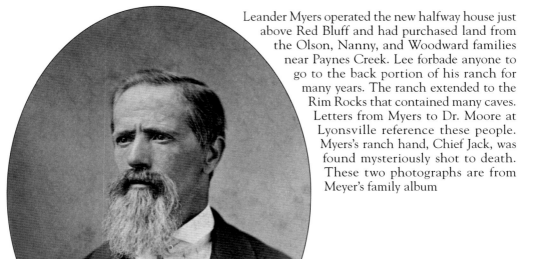

Leander Myers operated the new halfway house just above Red Bluff and had purchased land from the Olson, Nanny, and Woodward families near Paynes Creek. Lee forbade anyone to go to the back portion of his ranch for many years. The ranch extended to the Rim Rocks that contained many caves. Letters from Myers to Dr. Moore at Lyonsville reference these people. Myers's ranch hand, Chief Jack, was found mysteriously shot to death. These two photographs are from Meyer's family album

Sade Meyers was well bred and, along with her husband, was questioned about the large quantities of food she brought frequently for their stage stop and the Native Americans that worked for them. A trail led from the halfway house through the brush towards Paynes Creek.

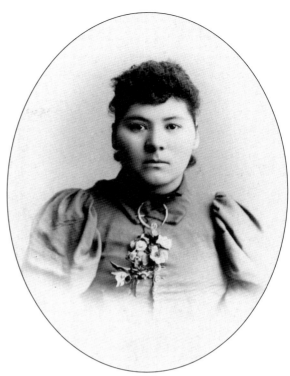

Native Americans Dora (above) and Cora (below) worked on the Myers Ranch when J. D. Reinhart took these photographs. The Meyers family assumed that they were sisters but little was known about them; they had been around since they were children in Red Bluff.

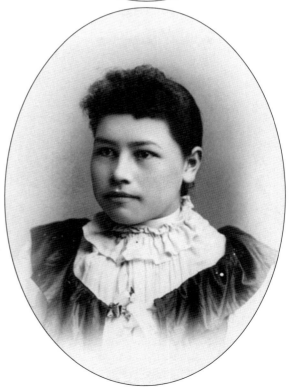

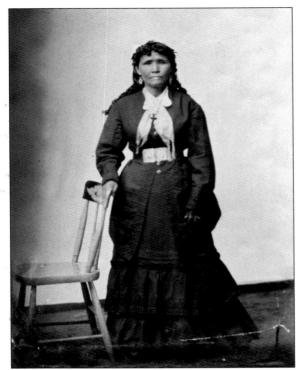

Mary Crocket Philpoot married Alexander Philpoot on August 20, 1857, in Redding. A Wintun native, she was born in 1845 and died in 1892. This photograph was taken around 1868 in a dress borrowed from Dr. Letha Jane Severn Shelton. Mary lived in Red Bluff.

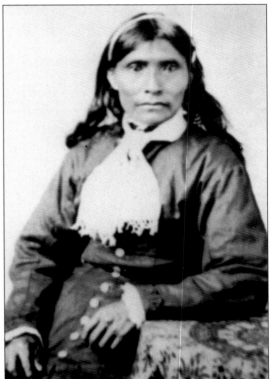

Taken 20 years after the tintype pictured above, Mary Philpoot had become quite acculturated, living in a house and dressing in fashionable clothes as the wife of Alexander Philpoot.

This is the sister of Mary Crockett, Angelina Courage Crockett, who died shortly after this tintype was taken. She is buried in an unmarked grave in the Oak Hill Cemetery in a segregated Native American section.

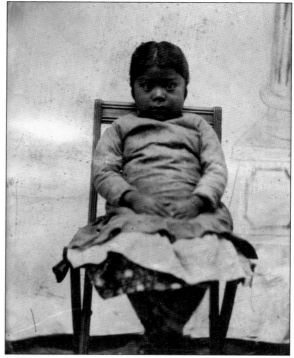

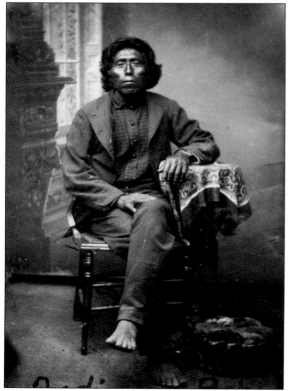

Chief Jack, seated here, was an early figure around Red Bluff. This is his only known photograph. He was shot dead by someone at night on the Myers trail near Paynes Creek during Indian raids. Jack had allegedly been seen at Graham's and Avery's place in Mill Creek raiding cabins. He worked for Leander Myers, running supplies from Red Bluff to Halfway House. Chief Jack is believed to be the son of Big Foot, chief of the Mill Creek Indians. He was one of the few survivors of the Mill Creek Canyon slaughter, brought out safely as a child of six years old. He was captured in his youth at age 23 in this rare tintype, taken around 1878 at Hogsback Ranch by a photographer named Dougherty from Lyonsville. (Courtesy Gurnsey family collection.)

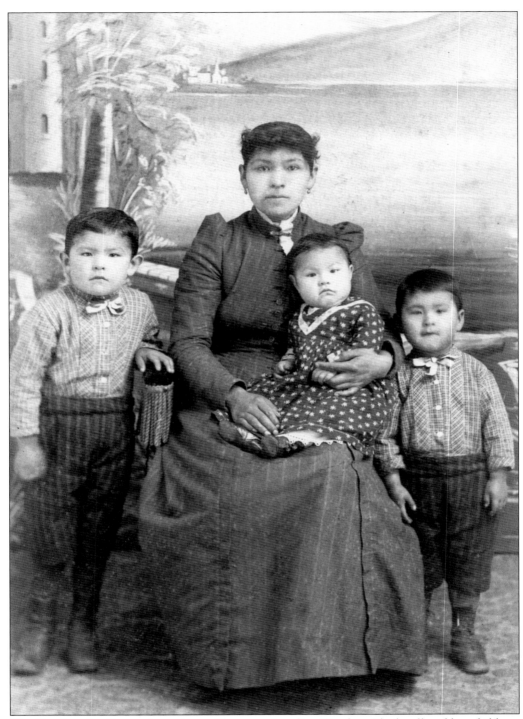

The Crockett family members pictured here are Angelina Crockett Blockwell and her children, from left to right, Toby, Mary, and Eddie. A traveling photographer from Yreka, Jacob Hansen, took this image in 1868 near Reeds Creek.

Due to hostile conditions, many Native Americans who returned to the area from Round Valley Reservation were relocated to other less aggressive areas. The images on this page show Minna, a girl who was found in the caves below Paynes Creek. Minna lived the remainder of her life at Brown's Ranch north of Yreka. She suffered from lazy eye and lost part of her sight very early. Minna was housed in the Red Bluff jail before being sent to Round Valley Reservation.

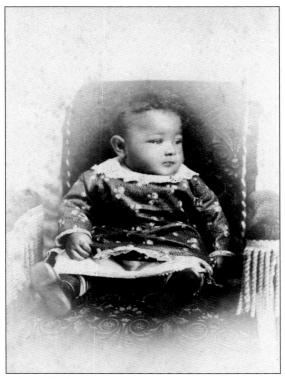

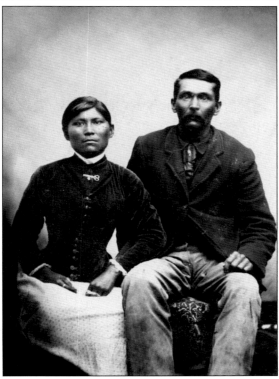

This is Indian Charlie (above), the son of Mary and James Rupert who pose for a tintype (below). These names were given to them by well-meaning Caucasians. James was originally found near Shakehouse Ravine living as a traditional Native American and was a familiar sight around Red Bluff. It is also assumed that Mary had adopted a Caucasian lifestyle. Both of them had almost become acculturated when this tintype was made in 1868. Living about two miles from Red Bluff, James worked at odd jobs. (Above courtesy Charles Avery Jr. family album; below courtesy Samuel Westrope album.)

Indian Charlie, son of Mary and James Rupert, came to live in Antelope Valley and later worked for Abner Nanney at Lanes Valley near Paynes Creek. Hobart Moulton reported that he is buried below a big oak tree near the wagon road at Moultons Loop. He was frequently in Red Bluff doing odd jobs and spent much of his time in the Red Bluff jail. He also worked at the halfway house on Hogsback Road.

Charlie Shelton is seen here in his mother's doctor's buggy. Indian Charlie was named for Charlie Shelton's uncle Charles, a white man.

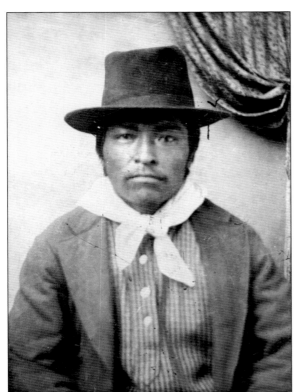

This tintype of an unidentified Native American was taken by a traveling photographer named J. D. Welsh around 1862 in Red Bluff. According to the writings of Nancy Westrope, the Native American was never seen again. Stories and sightings of "wild Indians" in and around Red Bluff continued until well past the turn of the century. From 1850 until 1911, when the famous Ishi, a Yahi, was captured, plunderings of cabins, murders, and other depredations were all automatically blamed on Native Americans. With the tales and horror left over from the Lano Seco Massacre, the entire region had been on edge with fear that had lasted for 50 years. Stories of what happened to many whites over the years had embittered an entire community, as well as an entire generation, and caused them to act on their fears.

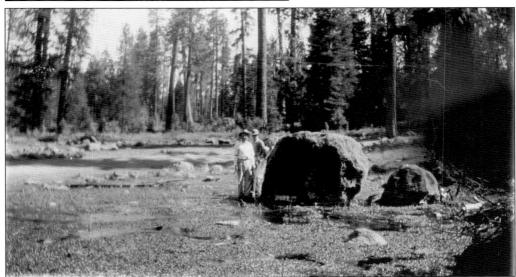

Annie Westrope also wrote vividly in her journal about the "real" war against the Native Americans, which was fought "within the minds of those scared and fearful souls," and which led to the final annihilation and snuffing out of an entire regional tribe. Pictured here in 1936 are Ed Olson and Tom Gibson visiting the site where the final battle was fought. This site is called Indian Meadow and the large boulder contains six deep mortar holes. It still exists today, though it is surrounded by large trees just off the Lassen Trail.

Six

THE INDIAN FIGHTERS

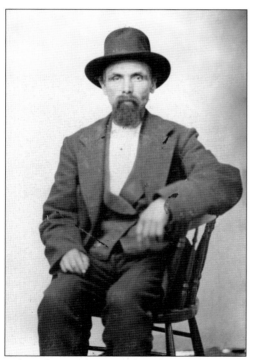 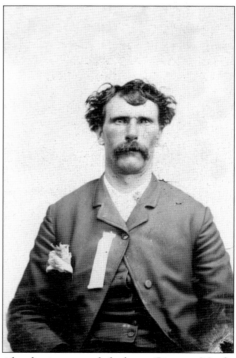

Taken during the period of the Native American raids, the image at left shows Simeon Moak, one of the most feared Indian fighters. He boasted that in his lifetime he had killed over 300 local Native Americans. His brother Jacob, seen at right, was just as feared among the Mill Creek Indians. The brothers killed every Native American they came across while on the raids, including women and children.

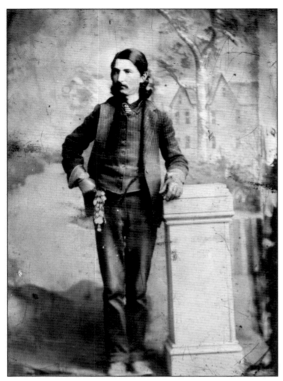

Sandy Young was John Bidwell's lead man, pictured here in his late 20s or early 30s. Fancying himself as an Indian fighter, he witnessed the aftermath of the Last Battle of Mill Creek. This tintype shows Sandy's holster covered with the coins that he had collected, allegedly stolen by Native Americans and recovered.

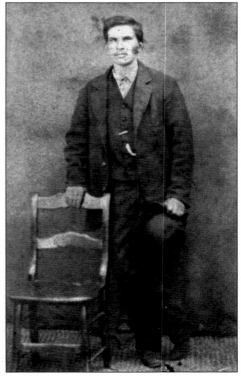

Bob Anderson also accompanied Hi Good and Simeon Moak to the Last Battle of the Mill Creek. Many Mill Creek natives were killed that day, including Big Foot, chief of the Mill Creeks, who was also known as Six Toes. (Hiram Good album.)

R. Lee Black rode with the posse that went into Mill Creek in search of Native Americans. Seen here at 22, he became a landowner and raised cattle around Antelope Valley and Red Bluff.

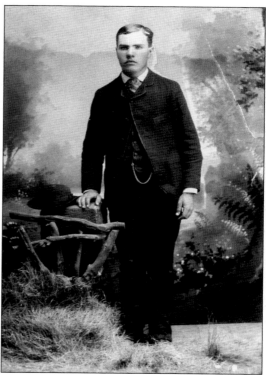

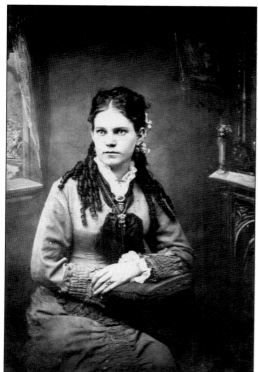

Beulah D. Flournoy participated in most civic activities and was an expert roper while riding sidesaddle. On one such riding trip, she was chased from the mouth of Antelope Canyon by a band of Native Americans. This photograph is marked, "W. T. Washington Red Bluff, Cal May 27, 1878."

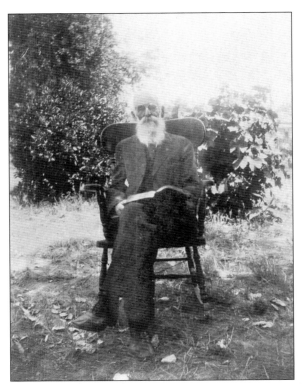

Samuel Westrope had accompanied his family across the Plains at age 43 in 1858. Pictured here on his 91st birthday in 1901, Samuel had fought against the Native Americans the day his son Daniel was killed. In 1904, when Samuel died, he was reportedly buried next to his son at Mineral. Here he is reading a family Bible (now in the author's collection.)

This tintype of an unidentified Native American was taken by a traveling photographer named J. D. Welsh around 1862 in Red Bluff. According to the writings of Nancy Westrope, the Native American was reportedly never seen again.

Seven

MISCELLANY

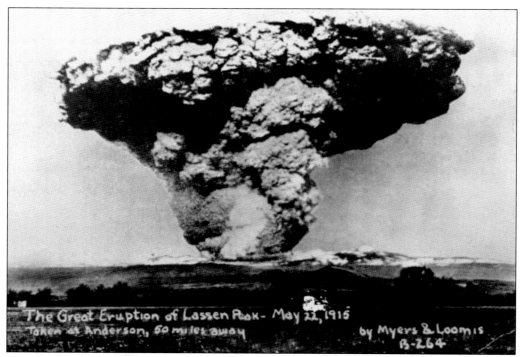

The Great Eruption of Lassen Peak- May 22, 1915
Taken at Anderson, 50 miles away
by Myers & Loomis
B-264

This view shows the violence of Mount Lassen's eruption as it appeared on May 22, 1915. The mountain began to smoke on April 28, 1915, as recorded in the diary of Alice Olson who lived on Grassy, Horseshoe Lake. She wrote that the mud pots (probably Bumpass Hell) threw mud 20 feet into the air. The Olsons, along with their neighbors, would hike out the back way and return to Red Bluff a few days after the May 22, 1915 blast.

As early as 1880, hand-tied fly-fishing lures were being fabricated by members of a family, and their handiwork would become world renowned today as the Powell Fly Company. Out of necessity, three women and one man began collecting local hides, furs, and feathers and fabricating them into fishing lures. Their first store opened at Sixth and Main Streets in 1907. Later moving to Marysville, the Powells became world famous for the split bamboo rods that were up to 12 feet long. They were first tied by Myrtle Powell, Bell S. Moulton, Alice Olson, and Charles Avery. Clyde Powell is seen above with bundles of straight-grained bamboo, destined for six-piece, split-bamboo rods. Powell Fly Company made the graphite rods for Robert Redford's movie *A River Runs Through It*. At left is a standard Powell Fly Company brochure written by E. C. Powell and given out at the Chico store as well as the one in Red Bluff.

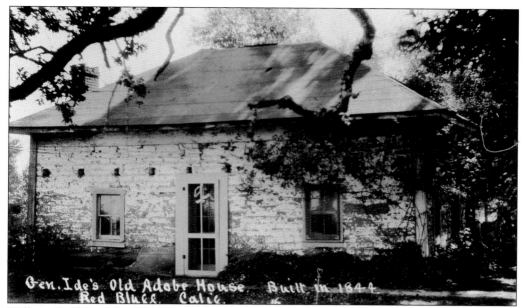

William B. Ide's adobe home was built in 1844 in what would become Red Bluff, on the banks of the Sacramento River. The tree limbs in the photograph are from a giant oak estimated to be 800 years old. Ide is buried in an unmarked grave in the Monroeville Cemetery. A marker commemorates the site near Ord Bend, California.

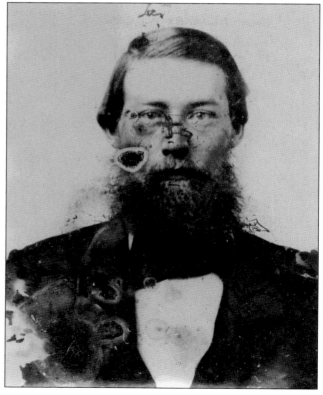

Though there are no known photographs of William Brown Ide, who founded the short-lived "Bear Flag Republic," this ambrotype, which was passed down from Sarah Ide and through the Cooper family, was finally given to Hobart Moulton (a great-grandson of Ide). Scratched on the back is "W. B. Ide." The case has long since crumbled and the image, purportedly taken around 1850, is very pockmarked on the glass.

Many successful businesses continued for over 50 years in Red Bluff. Three advertisements that shared space on the page of the Red Bluff paper in 1915 are W. H. Fisher Company (see page 36), W. C. Fickert Company (see page 46), and Lyon and Garrett Company (see page 102).

The lives and times of pioneers were filled with hardships. They came to Tehama County just like pioneers in other places, many with little more than the clothes on their backs. With no shelter and few provisions, they built their towns out of necessity. Encased in stone in the Lincoln monument at Oak Hill Cemetery are early records of Red Bluff and the county compiled by Mrs. Jessie Frank McKinney, a descendent of pioneers, who was on the fund-raising committee in the 1890s.

> Friend Alice
>
> These few Short lines which here I trace
> Years may not chnge or time erase
> They may be read though valued not
> When She who wrote them is forgot
>
> Mrs. M.E. Florence
> Red Bluff Cal
>
> March 3, the 1883

This is the final entry from Alice Olson's autograph album kept in Red Bluff and Lyonsville.

ACROSS AMERICA, PEOPLE ARE DISCOVERING SOMETHING WONDERFUL. *THEIR HERITAGE.*

Arcadia Publishing is the leading local history publisher in the United States. With more than 3,000 titles in print and hundreds of new titles released every year, Arcadia has extensive specialized experience chronicling the history of communities and celebrating America's hidden stories, bringing to life the people, places, and events from the past. To discover the history of other communities across the nation, please visit:

www.arcadiapublishing.com

Customized search tools allow you to find regional history books about the town where you grew up, the cities where your friends and family live, the town where your parents met, or even that retirement spot you've been dreaming about.